# Photography as Meditation

Torsten Andreas Hoffmann is an author, photographer, and conductor of photography workshops. He has written articles about image design for several magazines, including *Photography*, *LFI Leica Fotografie International*, *c't Special Digital Photography*, and *Digital Photography* (Hungary). In his workshops, Hoffmann leads participants toward their individual photographic path. He focuses primarily on black-and-white photography and conceptual photography.

Hoffmann became internationally known for his work *New York, New York*, a book of photographs of New York City both before and after the attack on the World Trade Center (Kunstverlag Weingarten). His classic work, *The Art of Black and White Photography* (Rocky Nook) is currently in its second edition. He has also published art calendars through German publishers Kunstverlag Weingarten, Dumont, and ars vivendi.

Hoffmann was born in 1956 in Dusseldorf, Germany, and studied education with an emphasis on photography at the Academy of Fine Arts in Braunschweig. He has gone on photography tours in many places around the world, including India, Indonesia, Mexico, Nepal, Turkey, the USA, the Sahara, and the United Arab Emirates. His work has appeared in numerous exhibitions in renowned galleries in Salzburg, Frankfurt, and Berlin, and has been featured in over 20 photography books. Numerous works hang in private collections. He is a member of the BBK Artists' Guild of Frankfurt, the Munich LOOK picture agency, and the German Society of Photographers (DGPh).

Torsten Andreas Hoffmann

# Photography as Meditation

## Tap Into the Source of Your Creativity

rockynook

Torsten Andreas Hoffmann (info@t-a-hoffmann.de)

Project Editor: Maggie Yates
Translator: Susan Schlesinger
Copyeditor: Maggie Yates
Layout: Hespenheide Design
Cover Design: Helmut Kraus, www.exclam.de
Printer: Friesens Corporation
Printed in Canada

ISBN 978-1-937538-53-8
1st Edition 2014
© 2014 by Torsten A. Hoffmann

Rocky Nook Inc.
802 East Cota St., 3rd Floor
Santa Barbara, CA 93103
www.rockynook.com

Copyright © 2014 by dpunkt.verlag GmbH, Heidelberg, Germany
Title of the German original: Fotografie ale Meditation
ISBN: 978-3-86490-031-0
All rights reserved

Library of Congress Cataloging-in-Publication Data
Hoffmann, Torsten Andreas, 1956-
Photography as meditation : tap into the source of your creativity / by Torsten Andreas
Hoffmann. -- 1st edition.
    pages cm
Includes bibliographical references and index.
ISBN 978-1-937538-53-8 (softcover : alk. paper)
1.  Photography--Psychological aspects. 2.  Photography--Philosophy. 3.  Composition
(Photography) 4.  Meditation. 5.  Creative ability. I. Title.
TR183.H63 2014
770.1--dc23
                          2014017097

Distributed by O'Reilly Media
1005 Gravenstein Highway North
Sebastopol, CA 95472

Meditation and photography have more in common than you might initially think: both deal with the present moment, both demand the highest degree of awareness, and both are most attainable when the mind is empty and free from distracting, outside influences.

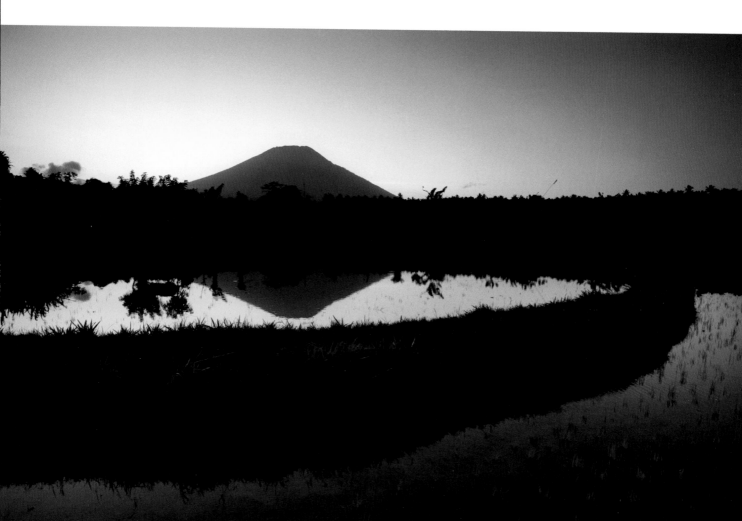

# Table of Contents

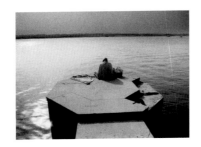

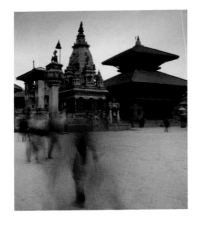

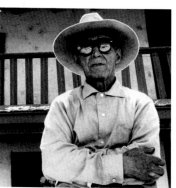

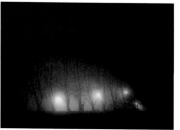

# 1

# Thoughts on Photography and Meditation

The recent phenomenon of mass accessibility to digital cameras has produced a generation that records everything, even the most benign moments. While this means that photographs have become a form of mass communication, it also means that millions of thoughtless photographs are taken on any given day. However, and despite the capriciousness of the art market, the demand for conscious, reflective photography has become even greater. For instance, the works of Andreas Gursky, one of the world's most highly paid photographers, have demanded close to a million US dollars for a single large-scale photograph.

Increasingly, people in the digital age of photography are beginning to crave their own inherent form of artistic expression rather than relegating their photography to simple snapshots. This book will teach you to develop your photography in a way that it becomes an expression of your personality. Photography reflects external realities, but also reflects the expression of your individual thoughts and feelings.

The act of photographing, and the resulting photographs, can be very emotional. The medium lends itself particularly well to capturing the variety of moods and feelings in the human range of emotion. This book will guide you to a meditative calm through a sensitive approach to photography, and help you develop your own form of photographic artistic expression.

The term *meditation* stems from the Latin verb *meditari*, meaning to contemplate or deliberate.

The term *contemplation* stems from the Latin verb *contemplates*, meaning to look at and observe.

Meditation and contemplation can help you discover what you want to express through your photography by accessing and bringing your creative flow into play. Contemplation has certain validity regarding photography because it denotes the act of seeing and considering. Photography is an art medium that compels you to find a quiet state of mind because it requires patience; good photography is generally not a product of a hurried mood. Photography can be a counterpoint to our often fast-paced and sometimes hectic way of life. Both time and space have become scarce in our society, and as a result, more people are interested in meditation and contemplation in order to recover and access their internal rhythm and balance. Meditation allows you to create an internal free space to breathe and exist free of distraction from the outside world.

Meditation and contemplation are common to a variety of religious practices and cultures, including Christianity and Buddhism. In this book, I will relate mostly to Zen meditation, which I consider to be very interesting because it is free from the dogma associated with any particular faith doctrine. I'll begin with the clarification of certain terms. The word "Zen" stems from the Chinese word "Chán," which refers to the meditative state. When I speak about Zen meditation, I'm referring to a deep immersion into yourself, aligning yourself with the core of your inner being.

By regularly practicing meditation, you can venture to the source of your creativity and produce images that have depth. That is exactly the premise this book discusses: locating your inner creativity through meditation and contemplation to fully understand your artistic motivations to produce meaningful photographs that have power that radiates for more than a few minutes, hours, or even days.

How to accomplish this using the assistance of meditation is a subject of considerable depth. This book is less focused on the classical criteria of image design than my book, *The Art of Black and White Photography*. This book is designed to encourage you to hone your creative process and put it in motion. Photography will always remain my foundation, but my many years of experience with Zen meditation naturally melds with my photographic process. It is my intention to present to you my personal interpretation of what it means to incorporate meditation as a tool in the photographic process.

"The greatest events are not our loudest but our stillest hours."                    Friedrich Nietzsche

*Japanese dry rock gardens (also known as Zen gardens or karesansui) invite meditation. Granite gravel (or sometimes sand) is placed around rocks, and then raked into patterns indicating the shape of water ripples. These special gardens serve to imitate nature conceptually rather than literally, and prompt contemplation on the true essence of the natural world.*

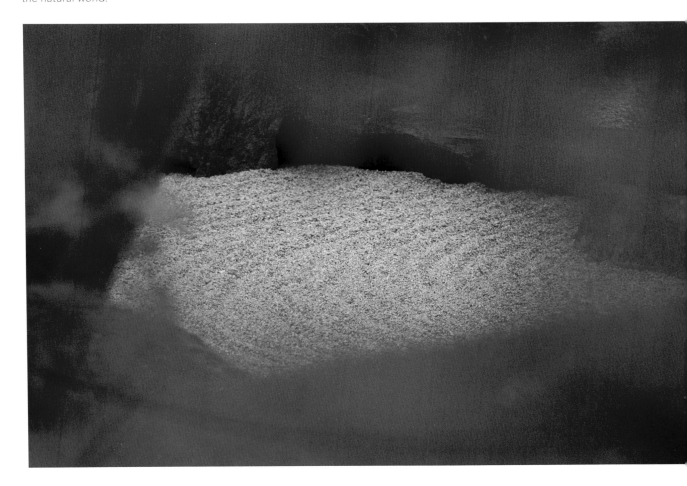

# 2

## Intriguing Ideas About Zen Philosophy

Zen meditation is a practice of Zen Buddhism. It migrated to China after the 6th century, and then made its way to Japan. It has since developed a presence in Western Culture.

Before taking a closer look at Buddhism, I would like to first stress that it is not my intention to convert anyone reading this book to any particular style of thinking; especially not a religion. The beauty of Zen is that it is a practice aimed at a deeper understanding of one's own mind and being rather than a religious doctrine. This practice of honesty and openness is an excellent foundation for meaningful personal artistic expression. While Buddhism is counted among the world's major religions, Buddhism is actually more accurately described as a form of philosophy. The essence of Buddhism is not to internalize any sort of dogma; instead, Buddhism strives to understand the nature of the human spirit in its deepest layers to find another way of seeing the world and one's own being. (Incidentally, photographers share this pursuit—they use their cameras to depict aspects of the world in fresh and insightful ways.) Today, Buddhism is mainly active throughout the Himalayan region and Japan; it also has a presence in Myanmar, Sri Lanka, and parts of India. In principle, it is a comprehensive philosophy that summons a transformation of the spirit and inner self to embrace all beings with deep compassion.

Several years ago I was granted permission to integrate texts from the Dalai Lama, the spiritual leader of Buddhism, with my photographs. I read many of the Dalai Lama's books and became captivated with his thoughts. What appealed to me was that the Dalai Lama doesn't intend to convert anyone to Buddhism. He emphasizes that anyone who embraces Buddhism can also keep his or her religion (or the absence thereof).

This tolerance also exists in the practice of Japanese Zen Buddhism. Zen meditation is even included in some Catholic monasteries as a supplement to the Christian spiritual exercises. Concepts of Zen teachings have also become visible in the realm of art, such as the Zen garden in the renowned Wolfsburg Art Museum. Zen Buddhism is, in my opinion, a philosophy or attitude bereft of dogmatic teachings, which may be why Zen often appeals to free spirits and free thinkers as a compatible spiritual refuge.

The fundamental thought of Zen meditation is the absence of thought. This slightly paradoxical statement requires further clarification: the phrase "absence of thought" is not intended to mean a careless attitude bordering on irresponsibility. More specifically it means being free of distracting thoughts that arise and hinder your awareness of direct experiences.

To understand and achieve this, it is necessary to thoroughly examine your own being. Zazen is the practice of seated meditation designed to calm the body and mind. Practicing zazen requires you to sit for a certain length of time, for example, 20 minutes a day, in a meditative position (I will explain this later) to attempt to find stillness in your mind. This undertaking is much more difficult than it first sounds.

If you actually sit in a place of stillness using a meditative pose where you are spared the influence of strong sensory stimuli, you will notice that you carry an inner storyteller within you. This storyteller will continually project stories and pictures on your mind's eye. The perpetual storyteller rummages through the past, rekindling old memories, or fast-forwards into the future and conjures up fantasies of days to come. If only these stories were at least exciting! Oftentimes they are repetitive recollections that you have already pondered thousands of times. This perpetual storyteller is ubiquitous.

For the most part, our constant internal monologue is not the least bit inclined to be silenced during experiences when we'd rather be present in the moment, for instance, when we are wandering through a beautiful landscape. It is precisely during these experiences that the perpetual interior chatter removes us from the experience. We are lucky when strong sensory stimuli override this background noise of the mind, allowing us to experience moments in a deep, unfettered way. Surely you have encountered such moments; moments in which you experience shivers down your spine as you behold a wondrous sight of nature. In these moments, stillness reigns in your soul—your mind is free from thoughts about your upcoming tax return or your disagreeable neighbors. Relieving the mind of superfluous thought is the intention of Zen. However, to define the condition of Zen as an objective to be achieved is missing the point; Zen is without intention. There is no five-year-plan to reach enlightenment.

Obviously, relieving your mind of nonessential thoughts does not imply that you should never think again. Quite the opposite: it is important and necessary to have the ability to think with structure, and to have the ability to form deep philosophical thoughts. The advent of smartphones and their ability to connect us to each other via the internet with immediacy has bred a culture in which we form many thoughts simultaneously. We are often in the middle of a thought while trying to accomplish an unrelated task when we could be experiencing something beautiful. At that point, the ever-thinking chatterbox is the master. You can exercise the practice of zazen, with its stillness and meditative postures, as a counter measure to these flurries of thought.

The practice itself is the goal. Through many years of applying this discipline, you will become intimately acquainted with the human thought process, complete with the ability to turn off its built-in thinking apparatus. You will learn how to subtly begin to distance yourself from the interior chatter of

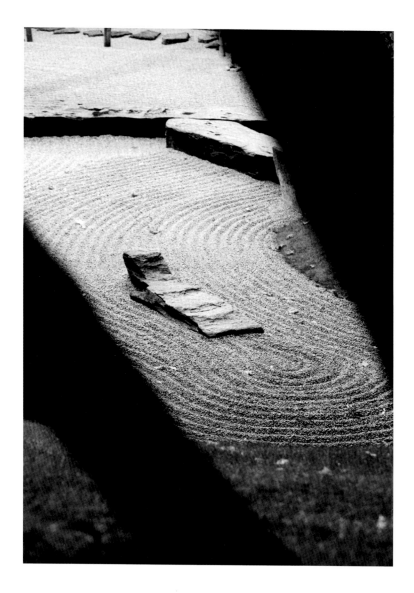

your mind, and with time, you can learn to increase the distance from intruding thoughts that jump into the peace of your meditative state, sidetracking you from the immediate experience. The essence of Zen is to release the voice of this internal storyteller and find your way back to what is real: the present moment. Everything else only exists in the realm of your thoughts and emotions.

This is where photography comes into play. There is almost nothing whose existence is based more in the present moment

than a photograph. Photography divides moments into an elapsed time of 1/8000 of a second.

If you've embraced photography, you have already found a practice that, by its very nature, keeps you in the present moment. Photography shares this wonderful commonality with meditation. When you sink deeply into the present visual moment with your camera, you can shut out the internal storyteller of the mind who continually tries to pull you from your focus. For some people, it is much easier to concentrate and remain in the present while composing a photograph than by sitting in zazen. While shooting images, you have the sensory stimulation of the external world in front of you to hold your mind's concentration on the present moment. When sitting in a calm place conducive to Zen meditation, ideally there is almost nothing occurring around you on which you can turn your attention. You are left alone with your mind; unless you've honed your meditative practice enough to completely ignore

your inner voice, your storyteller will be the only thing you're able to hear.

The goal of meditation is to experience complete stillness of the mind. When you achieve that stillness, the emptiness that exists in the mind won't feel empty at all. This paradox is one that is often presented in Buddhism—the idea that wealth comes into being from this emptiness. This concept of stillness or emptiness appears throughout the realm of the arts. The famous painter, Mark Rothko, spoke of the uncontainable power of silence from which the rare actual moment of stillness can arise. In his book *The Zen of Creativity*, American Zen Master and photographic artist John Daido Loori refers to this moment as the still point. Once you have reached this still point, you have arrived at the source of all inspiration and creativity. It is in this state that you might be kissed by the muse.

# 3

# Zen Is Not "Light"

Imagery trends in current lifestyle and travel magazines tend toward the expression of a "light" version of the world—only the most appealing aspects of places are featured. City views often appear slightly over exposed in the twilight hours, and the faces in the images are mostly of the beautiful and successful people. This sanitized version of the world does not correspond with the practices of Zen.

If you want to implement Zen into the art of your photography, do not expect the practice to lead you to experience this artificial, idealized version of the world. Zen is not concerned with the superficial. It leads you into the depth of your soul and shapes your view of the world from these raw, honest places. Zen will lead you to a photographic view of the world that is inspired directly from the silence and impartiality of your mind, leaving behind preconceived concepts of how the world should be. An important aspect of Zen is the process of learning to free yourself from automatic thought patterns and cliché notions.

> Zen will make us realize that the world
> as we perceive it is a multifaceted
> reflection of our own soul.

If you want to find your own form of expression through photography, it is very important to see through stereotypes and free yourself from them. Meditation can be helpful with this process. Zen meditation reveals the world to us as a multifaceted reflection of our own soul. The pictures that we take depict the intersection of our interior perception of the world and the exterior world that we capture at a particular moment in time. I will revisit the interaction between our perception of the world and physical reality in more detail in Chapter 15, "Inner and Outer Landscapes."

Through the practice of Zen meditation, you will find it easier to arrive at that deeper place within yourself. The deep understanding and connection to your inner being will enable you to create photographs that have the force to touch other people. Such photographs can be thoroughly beautiful, but they will not present the "light" version of the world.

The subject of a portrait does not have to fit the mold of the classical ideal of beauty. This peasant worker in Nepal wears the remnant tracks of life on her face and hands. This portrait is honest and, despite of the lines on her skin, there is dignity in the truth. Had this woman smiled, the portrait would have captured merely a snapshot in time. As it is, the picture reveals a true depiction of the subject.

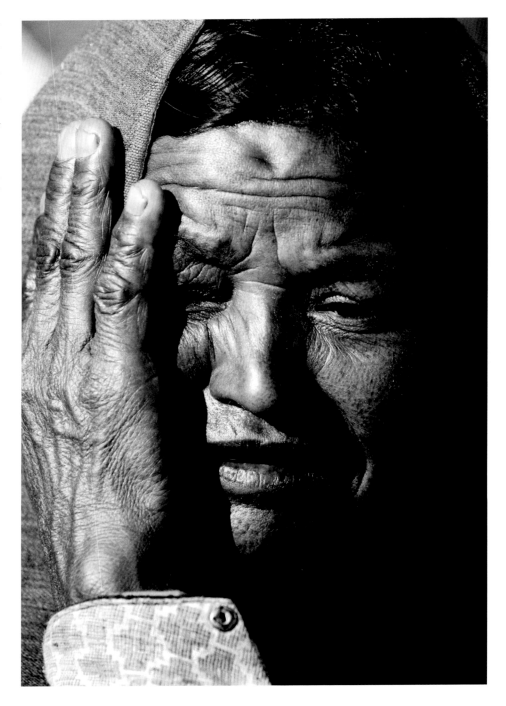

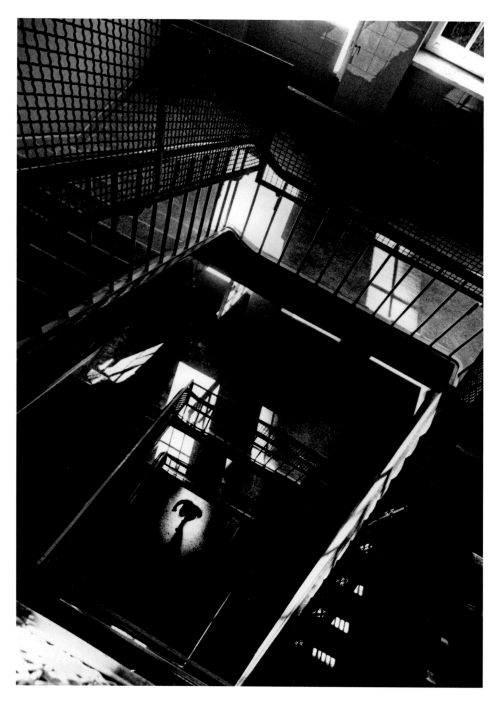

Without the figure running into the shot in the lower left-hand corner of this photograph, the effect of surprise and immediacy would be lost. The act of photography can be very similar to the act of meditation: remain vigilant and wait patiently for the perfect split second to press the shutter release.

# 4

# The Practice of Zazen

It is not my intent to force meditation on any reader. Therefore, those who would prefer not to explore the practice of Zen, as well as those who are already well versed in the practice of zazen, can simply skip this brief instruction.

The applied practice of Zen is called zazen, and is equally simple and complex. The external form is the simple part; ideally, one sits as upright as possible on a meditation pillow in one of three postures (see pages 19–21). These positions allow contact with the floor, which creates support for building a firm physical foundation. Another option is to sit on a meditation bench. For those who are not flexible or do not own a meditation bench, a chair can also be used to sit and meditate. In this case, take care to ensure that the feet remain in firm contact with the floor. Utilizing a nice quiet bench is also a good option if you find yourself wanting to meditate in nature.

Using any of the various posture options, sit as upright as possible and place the hands in front of your abdomen so that the fingers are interlaced below the belly and resting in your lap. The tips of your thumbs should touch one another and rest above the interlaced fingers next to your index fingers. Your eyes can be either open or closed to meditate. Traditional Zen practice calls for the eyes in an open position, gazing softly downward. You will need either a clock or an alarm so you can set a fixed amount of time for your meditation. I recommend establishing a meditation practice of 20 minutes; during this time your cell phone should be switched off and you should expect no interruptions.

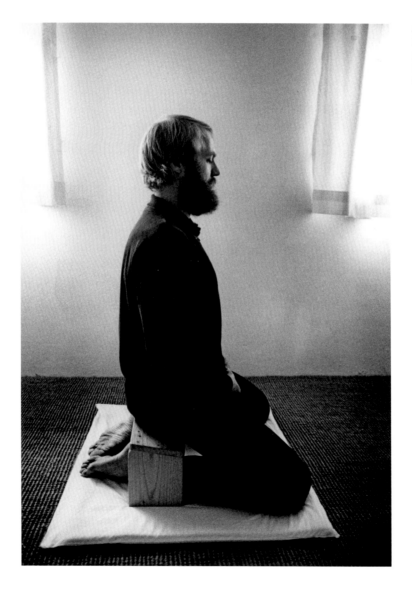

*A meditation bench lends itself well to zazen practice. In this position, the shins can be anchored to the floor.*

Once you're ready, your meditation can commence. Turn your focus directly to your breath. A technique for quieting the mind is to count each inhalation and exhalation. In this way, each breath is associated with a number in your mind as you slowly count from one to ten. When you arrive at ten, start again with the number one. Sometimes your mind might wander and you'll realize you've counted past ten. If that happens, simply start over with one.

In the beginning, 20 minutes will most likely seem like a long period of time. You may also notice that your mind is restless, and wants to focus on mental images or thoughts. In most introductory lessons on meditation, these images and thoughts are often compared to clouds. You can simply allow these clouds to pass by without giving in and dwelling on them. You can always return your attention to your breath. When you become more accustomed to the act of meditation, you'll experience periods of silence in your mind.

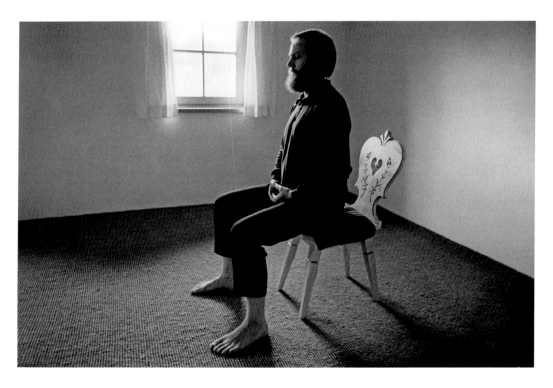

*Those who are not as flexible or don't own a meditation bench can meditate on a chair as illustrated. Pay close attention to the posture.*

*The most common position is to sit cross-legged on a meditation pillow, allowing the knees to connect with the floor to build a strong foundation.*

"In the pursuit of knowledge, every day something is added. In the practice of the Tao, every day something is dropped."     Lao Tzu

When you become more successful at recognizing distracting thoughts and refusing to identify with them, you will begin to see how thoughts and feelings are linked to one another. If you keep enough distance from these thoughts and allow them only to pass by, they will cease to exist. With practice, you will learn to become so minimally involved with the fleeting thoughts and images of your mind that you will experience moments in which your mind finds true stillness. These voids of thought will begin to occur more frequently and in longer duration. This feeling of stillness is positive, but is difficult to describe due to its personal nature. The focus and stillness brought on by meditation will be a unique experience to each person. It is important that you practice the designated 20 minutes of meditation regularly. After a year of practicing this exercise, you will notice that your 20 minutes of meditation is a little oasis in each day when your mind is open. You can retreat to this place and replenish yourself after intense moments in your life.

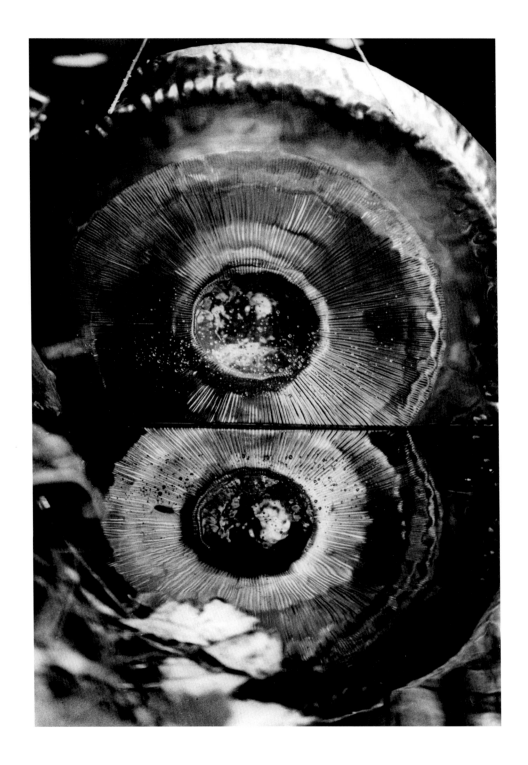

# 5

# Mysticism and Thoughts About the Absence of God

When you participate in meditation and the culture of Zen in general, you will encounter the word "mysticism." Many people use the word "mystical" without knowing its true meaning. Let's discuss the meaning of "mystical" and "metaphysical" in reference to photography.

Photographs are sometimes labeled as being mystical when, in fact, "moody" or "mysterious" would be more appropriate descriptors. The original meaning of the word "mystical" stems from the religion of mysticism, and refers to the concept of a personal and individual union with God. Every religion has mystical aspects; people attempt to transcend their earthly experience and achieve an intimate connection with the Divine through a variety of pursuits, including meditation, contemplation, and purification of the soul. Here, the term "Divine" represents the concept of another level of existence beyond the confines of the world perceptible with our limited five senses. The idea of such a level beyond our known world is age-old; the notion repeatedly surfaces in ancient cultures and philosophies. Meister Eckhart, a prominent Christian mystic, repeatedly withdrew into seclusion to purge his senses of saturation so they could be open for experiences with the Divine. In the Vedas, ancient sacred Indian scriptures, the world that we experience with our five senses is called "Māyā," which means "delusion."

A fundamental concept of
Buddhism is that the origin of
all things is beyond words.

Anthroposophy, the philosophy of Rudolf Steiner, also
adopts this idea that a spiritual world exists beyond our five
senses that can be recognized through awareness of our inner
being. Steiner claimed that one could experience this spiritual
world through specific training that developed the imagination
and intuition to exist outside of the direct sensory experience.
This may seem absurd, but consider, for example, the fact that
we can only perceive a fraction of the vast array of electro-
magnetic waves that flow continually through our world, and
it should become apparent that our senses give us a very lim-
ited scope of reality. Our eyes can see a range of wavelengths
between approximately 400 and 700 nanometers (between
infrared and ultraviolet) and our ears can hear frequencies
between roughly 20 and 20,000 Hz (between deep bass and
high tones). All waves and pulsations that are either above or
below these defined ranges are not perceptible to humans.
These concepts related to the world that exists beyond our
physical perception can be referred to as the "metaphysical
world."

Many philosophers, including Aristotle, were involved with the metaphysical. Karl Jaspers alone devoted an entire body of work to metaphysics. The term "metaphysics" refers to the philosophies and underlying theories of a field of study. The difference between metaphysics and mysticism is that mysticism stems from religion while metaphysics refers to content from all philosophical ideas. They are similar, however, in that they are both concerned with what can be fathomed beyond the perceivable world.

The term "God" is seldom used in conjunction with Zen and Buddhist philosophy. Zen is the attempt, through years of practicing zazen, to arrive at a plane beyond logical reason and verbal language. Buddhism speaks not of God, but rather of Nirvana, which is the state of mental stillness achieved after emotions such as desire and delusion have been conquered. Nirvana is about an emptiness that provides great abundance or fullness. This emptiness cannot be grasped with logical understanding. Ultimately, the essence of Zen is to break the shackles the logical mind has on our perception of the world. Instead of the term "God," Zen master Sokei-An calls this pure experience of the world "original consciousness."

## Can Photography Imply Mystical or Metaphysical Dimensions?

The following question arises in regard to photography: can photography extend into, or at least bear the suggestion of, a sort of mystical or metaphysical dimension? The connection between photography and metaphysics has already made

its mark in history. German photographer Herbert List was interested in the subjects of surrealism and photography that suggested the metaphysical. He created images in a style he referred to as "fotografia metafisica"; in these images, List used tools such as double-exposures and mirrors to suggest the metaphysical world. He presented things in strange, unfamiliar situations, or staged encounters between fragments of reality that had been uprooted from their original context. An example of his work is the image, "Santorini." This photo shows a fish swimming in a water-filled glass vase. The vase is sitting on a balustrade overlooking the wide, luminescent Mediterranean Sea—the water in the vase is superimposed over the water of the ocean creating the effect of overlapping realities.

Henri Cartier-Bresson's work is another example of how blending Zen meditation with photography can bear expressions of an incredible presence. In his own words, Cartier-Bresson described his art (his drawings, in particular) as a meditation. American photographer Minor White also embraced a mystical approach in his photography. During his unconventional workshops, he left his participants alone with an object (for example with a magic tree) for an entire evening before they were allowed to take a picture of it.

When viewed superficially, photography is certainly a medium that refers exclusively to visible realities. Yet, it has the potential to suggest at least the existence of other layers beyond those we can directly sense. The following photographs illustrate these concepts.

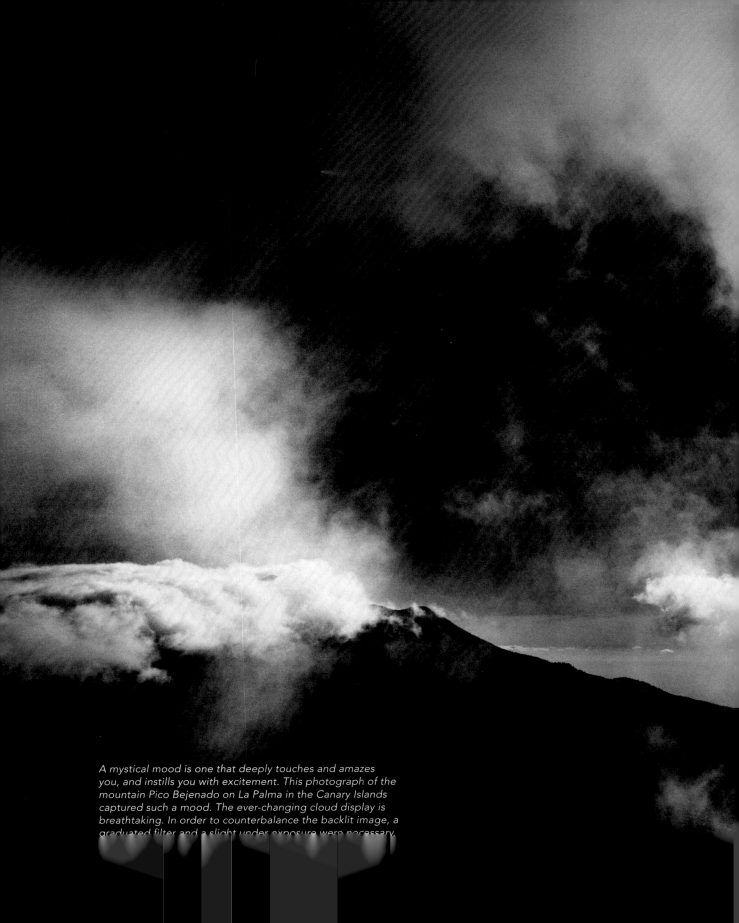

A mystical mood is one that deeply touches and amazes you, and instills you with excitement. This photograph of the mountain Pico Bejenado on La Palma in the Canary Islands captured such a mood. The ever-changing cloud display is breathtaking. In order to counterbalance the backlit image, a graduated filter and a slight under-exposure were necessary.

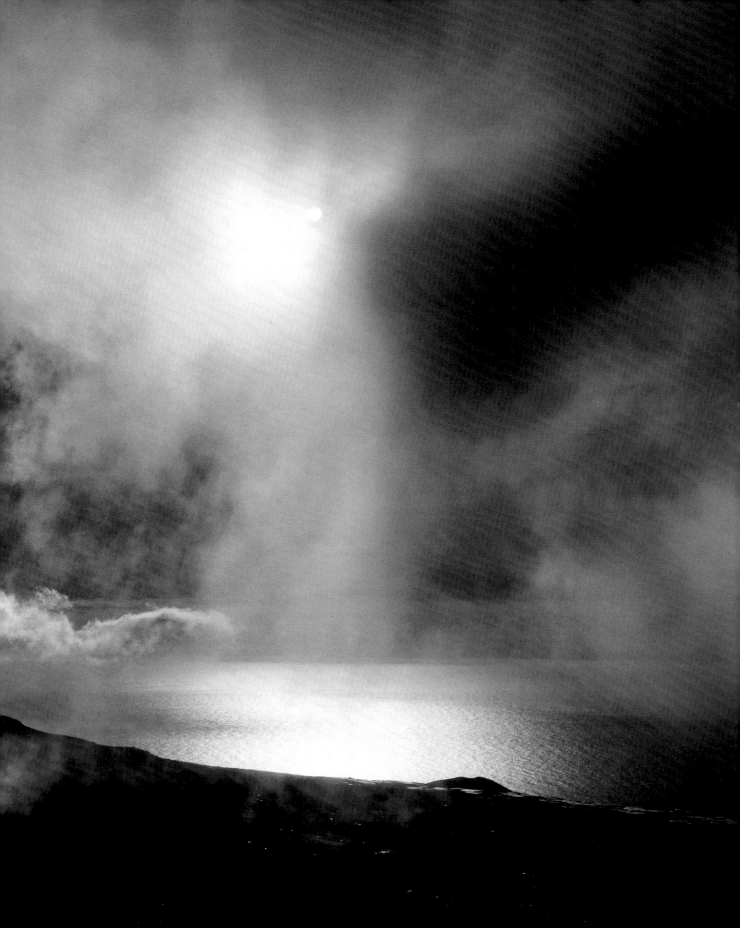

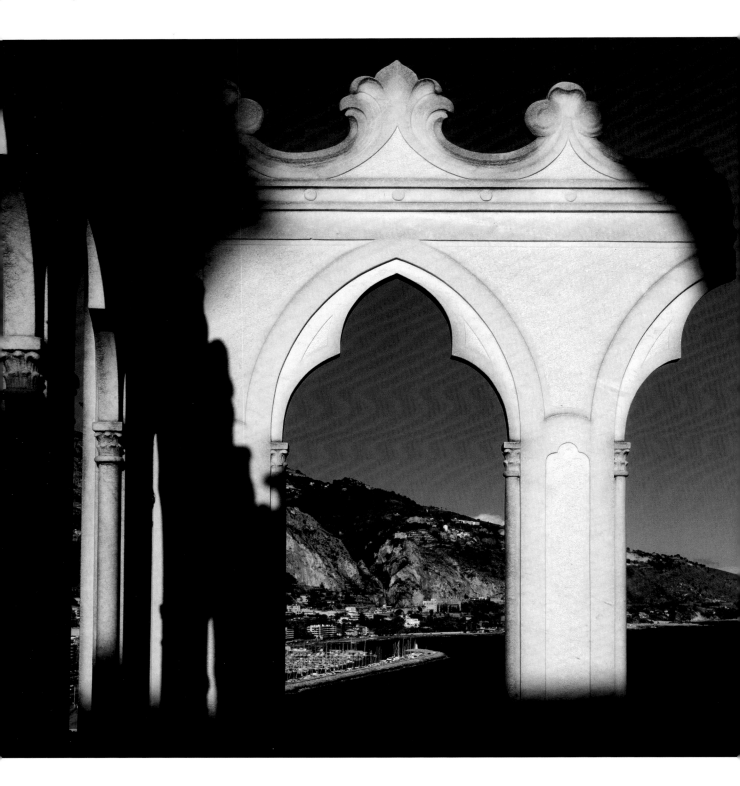

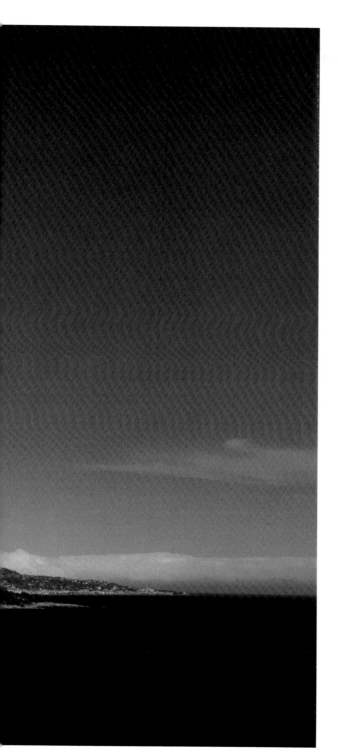

*The mystical, surreal effect of this image stems from the Gothic arch amidst the ruins in the French commune of Menton. This photograph hints at the mystery of time's passage. Applying a polarizer and a yellow filter in Photoshop intensified the areas of the sea and the sky to create a deep black tone, producing an overall dramatic effect for the image. As is the case here, black-and-white compositions often bring a striking interplay of light and shadow to the fore.*

This picture is "raining twine." The dark sky appears as a curtain with threads of rain above the shadowed water. Magical light glistens from behind this curtain. This photograph was taken in the Aegean Sea in Turkey.

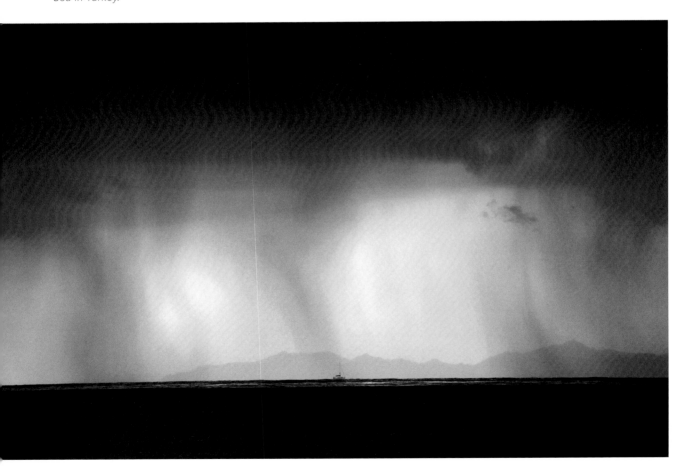

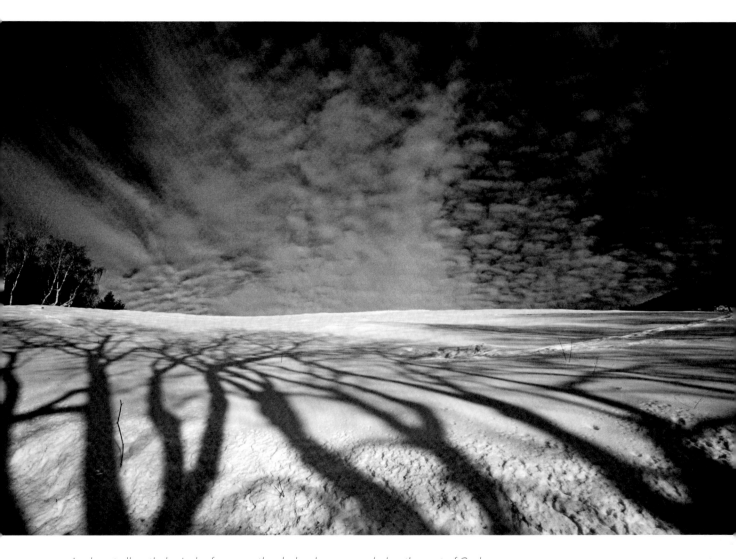

In almost all mythological references, the sky has been regarded as the seat of God or other divine beings; all the more reason to use a dramatically staged sky to refer to the mystical. You don't need to travel far to reproduce this kind of picture. This photograph was taken in Goslar, on the outskirts of the Harz Mountains in Germany. The contrast of the shadows of the tree on the snow and the clouds fanning-out over the sky give this photograph life. It always pays to watch the sky closely. This effect was enhanced with a polarizing filter and the yellow filter function in Photoshop.

Seekers of God frequently retreat into the desert to find them-
selves. It has been said that Jesus also went into the desert to
consider important decisions. Meditation means reduction. With
fewer stimuli to navigate, the senses are heightened and better
able to recognize significance. The desert is a landscape that can
be associated with the mystical: its starkness resonates closely with
asceticism, which is a lifestyle characterized by the lack of worldly
possessions in the pursuit of spiritual enlightenment. Both of these
photographs were taken in the Algerian Sahara Desert. Black-and-
white photography is an ascetic form of photography because it
represents a reduction of sensory stimulation.

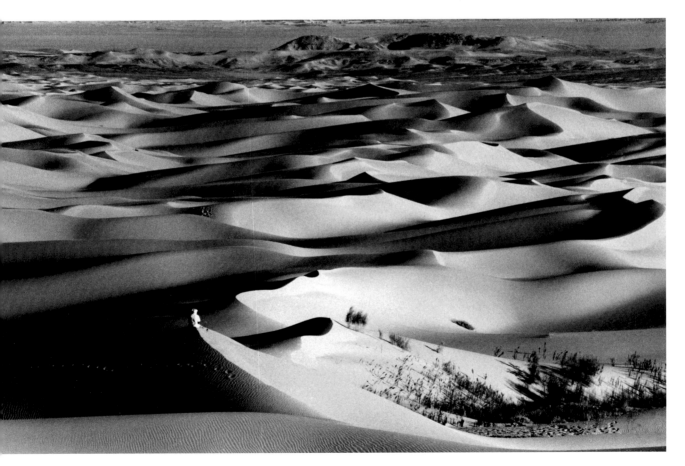

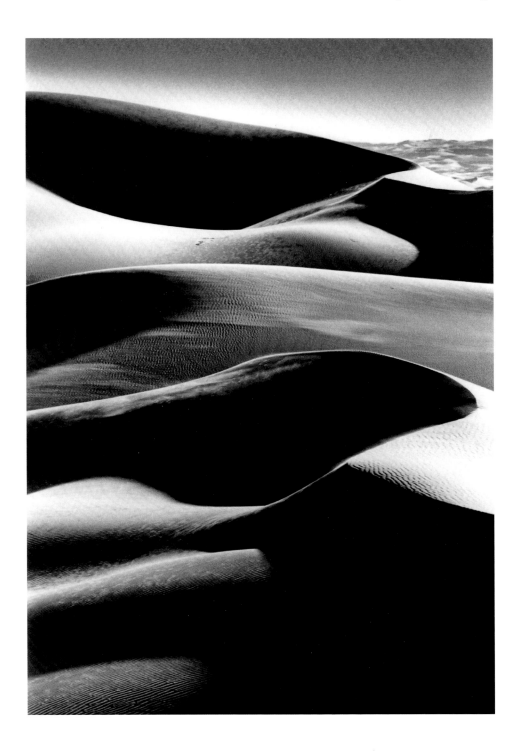

# 6

# Eastern and Western Thought

While technology has homogenized our world culture to some extent, the classic generalizations of "Eastern" thought and "Western" thought can still be used to some extent to illustrate how Zen and meditative practices, while still considered by some to be exotic or foreign, can be a tempering influence on the technology-driven lifestyles of people in the developed world.

In recent decades in the developed world (what we can, for the sake of this discussion, characterize as the "West"), the influence of science and technology has taken hold of society. We have, at our fingertips, larger compilations of information with greater attention to precision. This flood of detailed knowledge is so vast that a stronger presence of specialized expertise has emerged. One concern with this rapid change to a technology-based culture is that the "big picture" is becoming increasingly obsolete. As Aristotle accurately said, "the whole is greater than the sum of its parts"; herein is a prominent problem with Western thought: we try to discover truth by using empirical science and then applying logic and rational thinking to comprehend this information.

Using that logic and aptitude for science and technology, the West certainly has produced fantastic things. It would be inconceivable to imagine our modern lives without such inventions as the airplane or the computer; but the "big picture" cannot be grasped in this manner. The functions of logic and rational thought are housed in the left side of our brain. In the

"The whole is greater than the sum of its parts."                    Aristotle

West, structured thought dominates and flows from this side of the brain and progresses linearly. In Eastern cultures (for the sake of this discussion, "Eastern" refers to cultures that have their roots in India, Nepal, Tibet, ancient Japan, and ancient China), lifestyle is more influenced by the intuitive side of the mind in the brain's right hemisphere.

The philosophies of Hinduism, Buddhism, and Taoism bear tendencies of a more intuitive, mystical, and contemplative nature, which is more conducive to comprehending the "big picture," rather than simply enumerating and exploring the minutia of its parts. Hinduism and Buddhism share the idea that the manifestations of this world exist on a specific level and dissolve at a deeper level. Hinduism speaks of "Māyā," which is the delusion of the reality we perceive through sensory observation. As Western thought tries to dissect the whole into smaller pieces using logic, rational, and empirical data, Eastern thought tries to regard and experience the "big picture" as a single entity that encompasses all things.

As stated earlier, technology has allowed for the some level of cultural standardization throughout the world, and the classic ideas of both "Eastern" and "Western" philosophies have begun to influence each other. When considering everyday life, Western living is more likely represented by exaggerated activity while the Eastern lifestyle symbolizes a life of serenity. A good example of this is Japanese culture, which has both a bustling, technology-driven economy and a spiritual culture

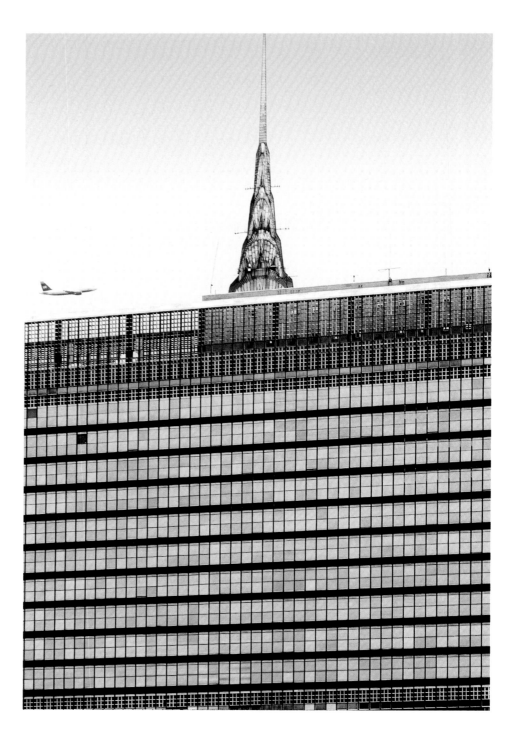

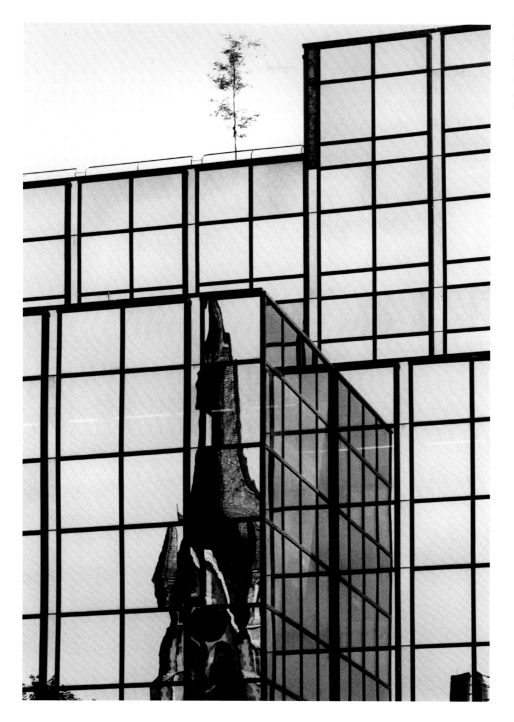

This image symbolizes
Western thought: it is
guided by constraints.
These photographs were
taken in New York City
and Frankfurt am Main,
Germany.

based in Buddhism; Japan is, most certainly, an Eastern culture in which Eastern and Western thought is in equilibrium. In the changing world, the East has become more structured and technologically advanced, and the West is gaining an interest in Eastern-based practices such as meditation, yoga, Chi Gong, and Tai Chi. This exchange represents a harmonization of the two human cerebral hemispheres: the more intuitive "Eastern" and more logical, rational "Western" mind.

Photography is a medium that is perfectly suited to balance and engage both halves of the brain. Above all, intuition is required to take the photograph. It is possible to successfully surrender yourself in a flow of contemplation and meditation when taking a photograph; however, when analyzing and processing the results using image-editing software, you should make good use of the logical, rational part of your brain.

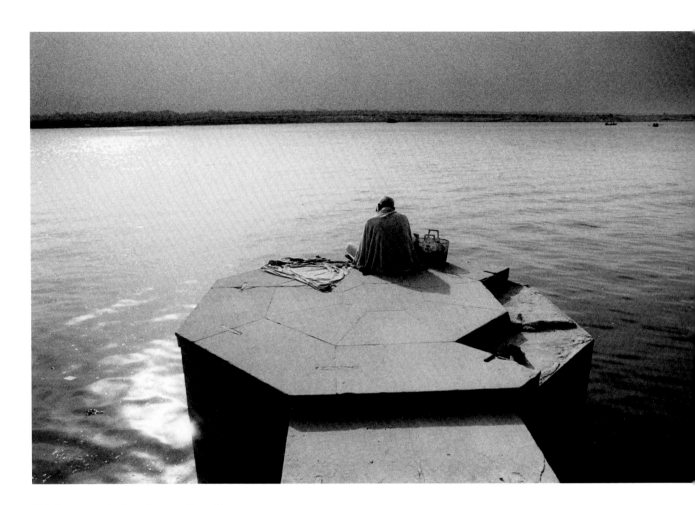

This image symbolizes Eastern thought.
It depicts an attempt to explore the "big
picture" through meditation and the power
of intuition. This monk is in the East Indian
spiritual stronghold of Varanasi—he is
sitting on the bank of the Ganges River,
reading the Holy Scriptures, and immers-
ing himself in his experience to become
one with God and the world. The closed,
centered composition of the photograph
emphasizes the idea of wholeness.

# 7

# File Drawers and Direct Experience

Usually we try to understand the world by organizing our knowledge and experience of it into a complex mental reference system. This reference system can be referred to as our "View of the World." This categorization process begins when we have an experience. While we are engrossed in the experience, we subconsciously begin to categorize the details of it into our reference system. Whether the experience is of a culture, a type of person, or a place, categorization involves an inevitable comparison to similar past events. We then try to evaluate the experience based on these comparisons in order to file the present experience into our reference system. Categorizing our experiences and packing them safely into file drawers increases our sense of security but reduces the intensity of the immediate moment. It gives us the sense that we already understand the world instead of allowing us to perceive moments with fresh eyes, like a curious child with an open mind ready for discovery. There is certainly nothing wrong with viewing the world with a rational approach. In many situations it can prove useful and helpful, for example, if we would like to orient ourselves in a city. However, the ability to see the world with an open mind can provide you access to new creative insight.

With contemplation and meditation, experiences and feelings do not require being arranged in a rational reference system to be understood or evaluated. To experience something

When we stop categorizing our perceptions in a rational frame of reference, we open ourselves to direct experience.

directly, as you learn through the practice of meditation, the rational mind should be as silent as possible during the experience. The rational mind judges, evaluates, and classifies, which inhibits our ability to experience the depth and immediacy of the moment. The rational mind labels everything in terms of language. The concept of an object is not the object itself, but rather our word for it. The famous surrealist painter, René Magritte, expresses this concept in some of his paintings. For example, he painted objects, such as a pipe, and labeled it with incorrect terminology. He wanted to encourage the viewer to observe and contemplate the painting without the preconceived notion associated with the term "pipe." The automatic associations we make between objects and our words for them diminish our potential for an honest experience interacting with that object.

In his book *A Wilderness of Mirrors*, author Max Frisch also considered this concept of how the traditional frame of language can be restricting. This is relevant to meditation, in which we attempt to sink more deeply into reality without reducing the experience by using language to frame and categorize it. Reality itself is nothing more than the experience of the present moment. By gaining the ability to encounter and process immediate experiences without compartmentalizing them into a file drawer of terminology, you will gain greater access to your creativity.

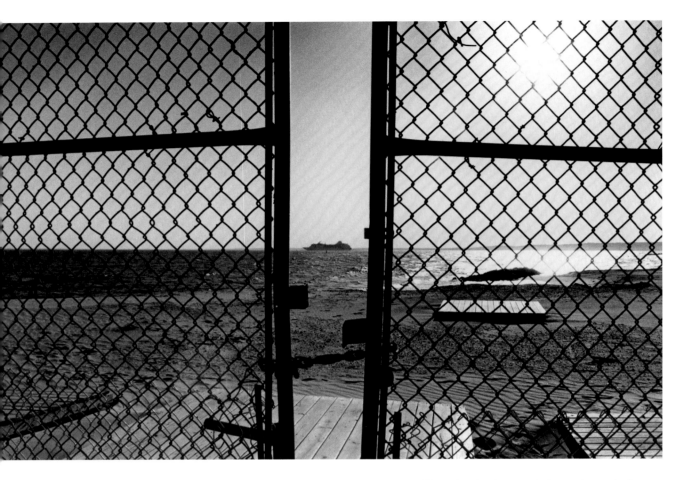

*These two landscape photographs symbolize our typical approach to seeing the world. Instead of experiencing the landscape in a pure capacity, we are distracted by thoughts of how the chain-link fence and concrete structure hinder our ability to experience the natural beauty beyond them. Through meditation, we attempt to find our way back to the immediacy of the experience.*

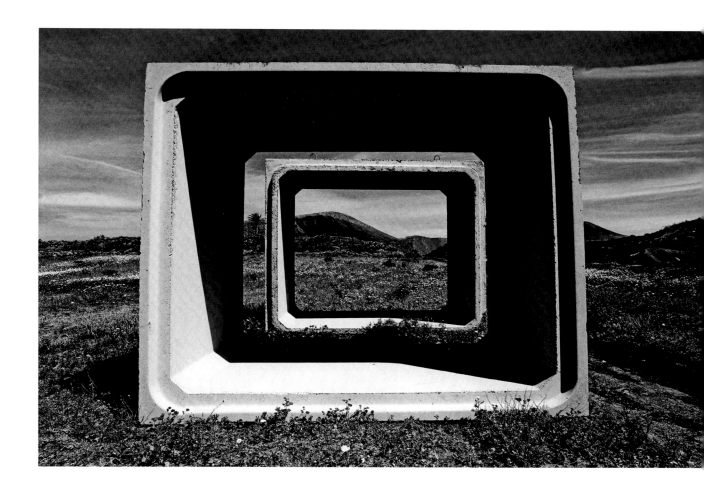

# 8

# Anecdote

While studying art in my early twenties, I discovered black-and-white photography. What appealed to me at that time were grim, dark compositions of buildings or torn billboards. I was also inspired by the collages of Dada artist Kurt Schwitters. I realized how wonderful it was that time leaves tracks and remnants from all the things that man created.

Before my first solo exhibition, I took part in a group exhibition of the Brunswick Professional Association of Visual Artists (BBK). Of the many artists in attendance, I was the lone photographer. One weekend, I was required to attend the exhibition to keep watch and conduct sales calls. Generally you receive very positive reactions at these exhibitions, but my experience was quite different: an elderly woman approached me and commented that she enjoyed the group exhibition very much, with the exception of the horrible black-and-white photographs. She blushed with visible embarrassment in regards to her remarks when I revealed that I was the one who had taken those photographs. I was amused by her comments, and I asked what she didn't like about the photographs. She responded that everything looked so dingy. She wanted to know my reasons for photographing springs from a discarded bed frame and then placing the picture in an art exhibition. I proceeded to give this woman a somewhat lengthy lecture about what exactly moved me to take such photographs.

First I explained that I was interested in capturing the physical characteristics and graphic lines of the railing and springs of a discarded bed frame. These features, combined

with the organic structure of the backdrop wall, were what fascinated me. I tried to explain the importance of observing images with detachment from our preconceived thoughts. I told her that if she looked at the image and categorized the contents via verbal language to "rusted-out hand railing and discarded bedsprings," she would be limiting her perception by encasing the images in a small prison. This would make it impossible for her to consider the beauty of the forms without prejudicial thoughts. She explained to me that she associated

the bedsprings with her experiences during World War II. From her perspective, this negative association was understandable; however, it still placed the image into the confined space that I referenced previously. I encouraged the woman to look at the image again, and to try to view it independently from her personal experience.

As our discussion continued, I told the woman that I didn't appreciate the aesthetic of current home renovations. At the

time, many old German houses were being refurbished in a manner that made you feel as though you could lick their new colors as if licking the candy coating of a raspberry popsicle. To me, it seemed very superficial. I would consider it much nicer to be able to recognize the traces of time on an old building. I then showed the woman the above image of a door and tried to communicate that if that door had been in Germany, the remnants of the poster on the door would have been removed long ago. I talked about how beautiful it is to recognize that the passage of time creates mystery.

In closing, I told her, that experiencing images of such doors could be romantic, and that I felt that kind of romance has gone missing in modern times. I additionally explained that a photograph must be composed in the same manner as composing a painting. Suddenly, she inquired about the prices of my photographs. At the time, I thought a price of 200DM per print was reasonable. She didn't hesitate and proceeded to buy all three prints. Furthermore, she asked me to inform her of my future exhibitions. I didn't know exactly what had happened, but in my life, that transaction is the one I remember the best. It was also my first.

# 9

# Is Photography a Life Experienced Second-Hand?

When I was younger, I regarded photography with ambivalence. I originally wanted to become a painter and paint like the American realist, Edward Hopper. The first paintings that I created during my years as an art student were not bad, but I soon realized that I was too impatient for oil painting. Photography became my medium of choice.

When I was on the island of Gomera in the Canary Islands, a young woman asked me if photography was a type of substitute life. I was impressed by this profound question and have thought about it often. Can the act of taking a photograph truly be as immediate an experience as our actual life? Or is the act of viewing those moments through the camera's viewfinder enough to remove us from the flow of the actual experience?

At that time, I was reading the works of Alan Watts, who characterized the Tao life of the Western man as follows: The Western man lives as though he is walking toward a river. Rather than experience joy in the flow of the river, he takes many canisters with him to the river, fills them with river water, and carries them home; only to wonder when he gets there, why the water no longer flows.

This description moved me very much. It perfectly described what I believed to be the true essence of photography. We head out into the world, but instead of surrendering to experience the flow of beautiful impressions in front of us, a beautiful landscape for example, we remove ourselves from the experience by watching it through a technical device. Then we take the captured images home in frozen form so we can reflect on them. I've experienced countless photographers acting as foreign bodies, causing disruptions at cultural events or religious rituals of an exotic culture. They strongly interfere with the natural flow of the ritual. It appears as though they were briefly emerging from the flow of life, which they could have experienced firsthand, in order to have a print to enjoy at home.

Because of this, I struggled with the decision to pursue photography as a way of life. A former professor once told me I needed to become a photographer in order to be able to experience my deeper self. I may have had trouble with the idea at the time, but I've since grown to agree. Readers of this book, as well, certainly regard photography at a higher standard than as a way to acquire snapshots. If you view photography as a medium of creativity, it must never be separated from the flow of a deep experience. Similar to meditation, photography can be used to bring you to a different flow of life. To experience reality through the lens of a mechanical apparatus and have it become a reality is an integrative act of creativity. A distinctly original flow of life emerges, completely different but no less intense and vivid than the one outside the camera.

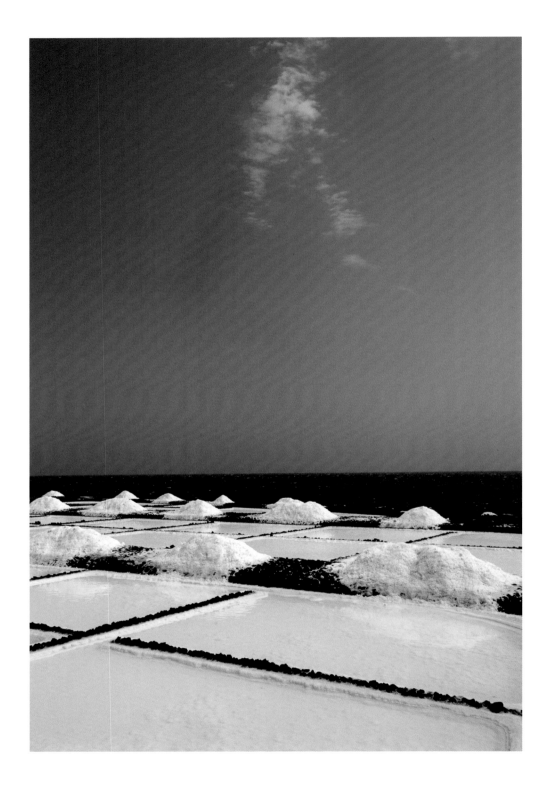

This photograph of the salt extraction on La Palma shows water that has already been "captured." Against the background of the ocean, water that still flows freely, this photograph symbolizes Alan Watts's concept of how photography can be likened to approaching the running water of the river and filling containers to take with you, only to find when you return home that the water no longer runs. This difference between the salt-extraction pools and the sea is striking.

Often photographers are troublemakers. Sometimes photographers (myself included) can stick out at foreign rituals or events. You can see an example here with the photographer at this Hindu ceremony on the Indonesian island of Bali.

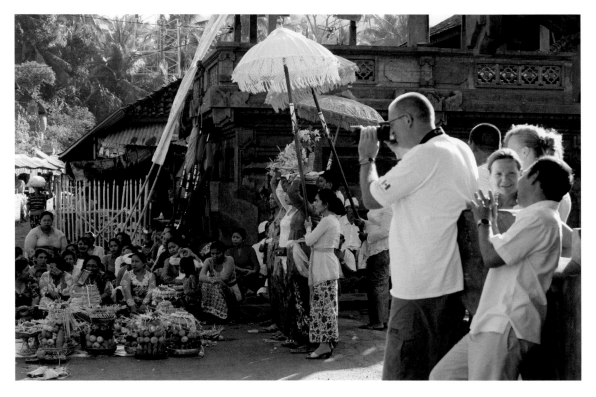

# 10

# Photography as a Direct Experience

In order to experience photography in a deep, transformative sense, you must enter a more contemplative and meditative state of mind. You must free your mind of thoughts and judgments and submit to the influence of your surroundings. For example, I enter this contemplative mode when I photograph in New York City. I no longer walk around thinking, "this is the Chrysler Building, which was built in the Art Deco style of the 1920s, and is the most beautiful building in the city." (You can, of course, revisit these thoughts at another time.) When you transcend into a truly meditative state, you automatically cease active thought. Simple observation is enough to allow you to become aware of the continual melding of the self with your surroundings. The "self," or ego, which judges and evaluates, fades and disappears. You suddenly become the Chrysler Building and switch your camera lens without thinking. It's as though the pictures are taking themselves, rather than being taken by you. Everything happens automatically. Seized more and more by the flow of the city, by the flow of the images, you enter a stream of enthusiasm and emotion. Now and then the knowing mind might make itself known, but once you acknowledge it, you return to the immediate experience.

When the ego, which judges and evaluates fades away, we can truly begin to see impartially.

Of course, such an enthusiastic, intimate flow can hardly be described with words. Ultimately, it is about choosing not to structure your thoughts with language. When I suddenly attempt to use language to describe what lies at the heart of the matter, I inevitably face a dilemma: what has happened cannot be described with words; it must be experienced. Photographs that have been created using this flow methodology bear evidence of this. Mere words fall flat and short of the mark. And yet, in this book I have attempted to describe the meaning of meditative photography in both words and pictures. This experience isn't rare and inaccessible. On the contrary— we have all experienced these moments of pure understanding. My intent isn't to describe these experiences, but to help you become aware that such intimate moments are different from the way we most commonly experience the world around us, and thus, can lead to greater creativity.

Photography can be an intimate experience and a meditation, but make sure
you master your technology so that the mechanics become second nature.
This way you can stay within your meditation without having to actively think
about setting a wide-open aperture in order to have the elements of this
picture in New York appear out of focus.

*It is wonderful to get into a flow of taking images that is not controlled by the rational mind. When the mind is labeling the subjects of your photographs ("This is the Empire State Building, and for a while after 9/11, it was the highest building in NYC . . ."), it is difficult to find that flow. Meditative photography is about finding calmness and stillness in the mind so photography becomes organic and authentic.*

# 11

# Duality Dissolved

The normal human condition is to live in a duality. In this state of being, we perceive the world separately from our own existence, and distinguish between subject and object; however, almost everyone has a desire to experience unity. Meditation deals very strongly with this idea that the duality between the perceiving subject and perceived object can be suspended. Zen Buddhism speaks of the non-ego, and present the idea that you can learn how to dissolve the ego.

We have multiple entities within our being. The entity within us that continually produces thoughts and images is the same entity that creates the illusion of the ego. But when this entity is silent, the boundaries between the perceiving body and the perceived world temporarily dissolve. The ego becomes the non-ego. If the temporary dissolution of the thinking ego is successful, it will be possible for the duality of our common state of mind to be temporarily replaced with an experience of unity.

Through the absolute emptiness
of the mind, the separation between
the perceiver and what is perceived
disappears.

When the mind is empty, the separation between subject and object disappears. This experience generates a profound sense of unity. This reward occurs rarely, if at all, in the early experiences with meditation, but will become more common as you continue your practice. This dissolution of duality can also occur during photography. I have briefly described how to lose yourself in the moment of shooting an image. These moments are by no means always available, but when they are, the successful result is an expressive photograph. The Buddhists refer to such an enhanced state of meditation as "Samadhi": in this state of heightened awareness, the duality between the photographer taking the picture and the subject being photographed dissolves.

The act of photography means finding the intersection of the interior and exterior world, and diving meditatively into this intersection with your camera. The aim of the photograph is to unite these two worlds. This macro image of the fibers of a palm leaf creating two transecting circles, one outside and one inside, symbolizes this intersection.

*This wonderfully shaped branch symbolizes cohesion through unity in diversity. This backlit image was taken using a macro lens, which rendered an image reminiscent of a Japanese ink painting. The image also bears a resemblance to the symbol for infinity.*

# 12

# Studium and Punctum

French philosopher Roland Barthes discussed his thoughts about photography in detail in his book, *Camera Lucida*. His thoughts about the distinction between the studium and punctum of the photograph are particularly well known. Studium indicates the factor that initially draws the viewer to a photograph. It refers to the intention of the photographer; the viewer can determine the studium of a photograph with their logical, intellectual mind. Studium describes elements of an image rather than the sum of the image's information and meaning. The punctum of a photograph, however, contains a deeper dimension: the elements of punctum penetrate the studium—they have the ability to move the viewer in a deep and emotional way. Barthes refers to punctum as the element in the image that shoots out of the context of the image like an arrow and pierces the viewer.

This idea of an arrow has a connection to Zen. In his classic book, *Zen in the Art of Archery*, Eugen Herrigel describes how he mastered, over the course of many years, the proper stance for archery. The reader quickly realizes that archery, in the context of Zen, is not just a matter of hitting the target. It has much more to do with an inner stillness, with holding a posture that allows you to let go of intent. In the context of photography and shooting images, the photographer must be at the right place, with the right lens and the right aperture, at exactly the right moment to capture the picture. Successful images, however, are not guaranteed based solely on having the correct

posture and intent. However, by letting go of intent, the stillness of the mind can take over and you can attain oneness with your surroundings. Barthes refers to this concept using the term "satori," which describes the highest state of enlightenment and comprehension in Zen. I prefer to use the term "Samadhi," which indicates a state of utmost vigilance and attention. Photographs taken while in this state may achieve the quality of punctum.

It is very difficult to evaluate your own photographs and judge whether or not they have the quality of punctum. Experiencing punctum is very personal, and the condition as Barthes describes it will present itself differently to every observer.

*I believe the following pair of images, both from my series "Janus Views," in which I show the rear and front views of the same location, achieve the state of punctum. These photographs were taken in the slums of Kathmandu, Nepal. From the onset, I was impressed by the friendly nature of the people living in these slums, and surprised that no one tried to beg for anything from me. The slums of Kathmandu are on the Bhagmati River, which runs through the city. For many years, this river has been a stinking cesspool. I wanted to show the contrast between the slum huts and the new, elegant buildings on the other side of the river using the Janus View technique (inspired by the Roman god, Janus), which shows a scene from two different perspectives: the scene in front of the photographer, and the scene behind the photographer. The young girl in these photographs deeply impressed me. Through my translator, I communicated the intent of my photograph. The girl remained natural and in exactly the same position as when I first encountered her. As I shot the pair of images, I felt confident that I had expressed exactly what I had intended to express. I am still touched by this pair of photographs today. For me, the stance and expression of the young girl exhibit extreme despair and hopelessness. After visiting these slums, I swore to myself that if anyone in Germany was whining about something, I would show them this set of images. Of course, I can't decide if these two images will trigger punctum in the eyes of a viewer, or if they can bring perspective to members of the over-satiated Western society.*

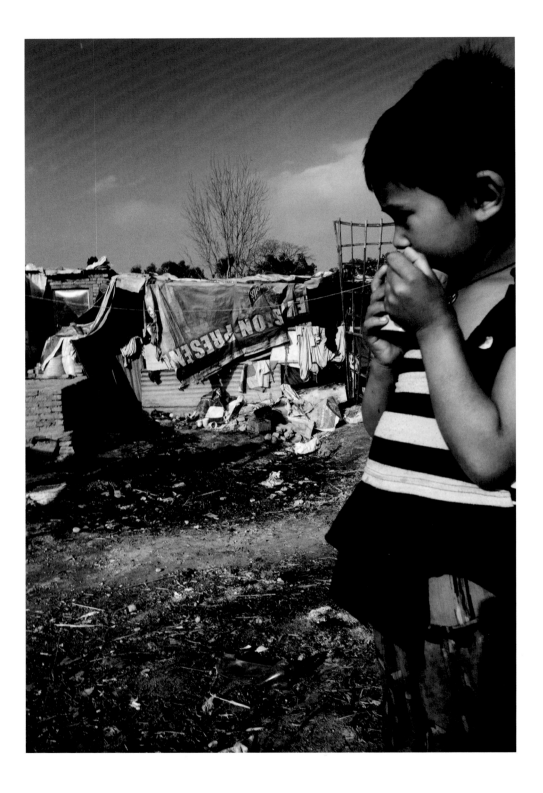

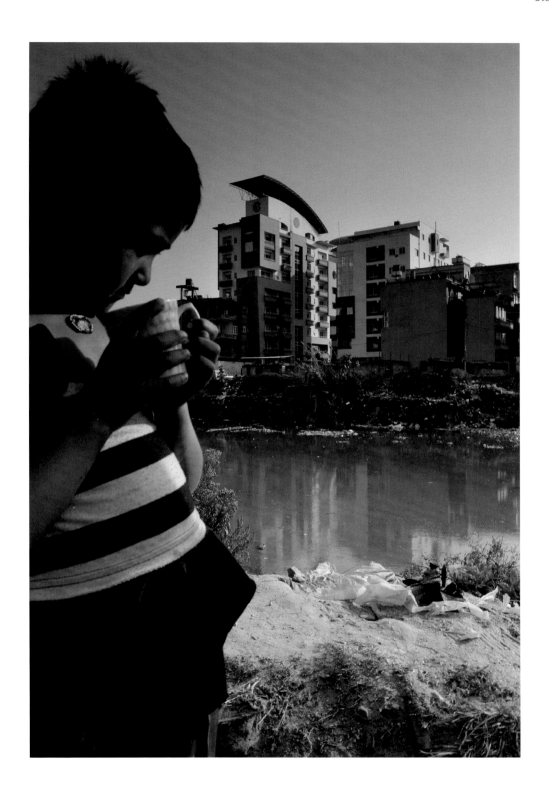

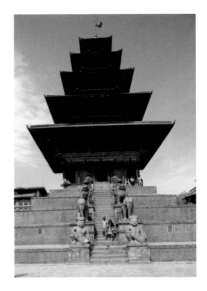

Punctum can be present in photographs of conventionally beautiful subjects. This pagoda temple in the Nepalese city of Bhaktapur was photographed in a variety of ways: the top picture is an average, hastily shot "tourist photo." It was taken with a wide-angle lens to assure the entire structure is in the photo. The studium the observer experiences in this photo can be described in terms of the physical aspects of the temple: its five roof surfaces, and the large statues that adorn the staircase.

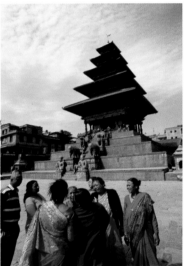

The photograph below shows a group of women in the foreground of the temple. The studium is the information that is provided about the local people and clothing of the region. In contrast, the larger photograph (opposite) is quite different. In addition to providing information about the pagoda temple, it also conveys a mood that is both mysterious and mystical. The blue sky is gone, replaced by reddish-brown. This photograph was created in a very different way from the others to achieve this result. Both of the other pictures were shot quickly; when taking this shot, I allowed myself much more time for setting up the shot. I used a tripod, and I added a gray filter to the lens. In order to achieve a more dramatic effect with the sky, I used an additional graduated filter. I sat comfortably on the facing wall and calmly observed the moments as they passed. Over a period of about 30 minutes, I pressed the shutter release about five times. I perceive this shot as the most successful of the three. I can't judge whether my photograph contains punctum, but, in contrast to the other two shots, this image appeals to the viewer's emotions rather than their intellect.

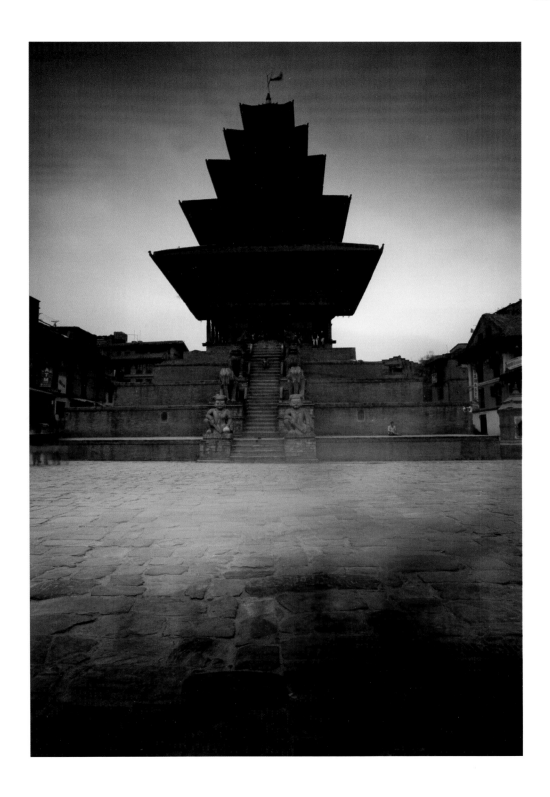

The next three photographs are of landscape images. These photographs provide examples of and further illustrate how studium can develop the characteristic of punctum. The top small photograph is a beautiful but inconsequential and common landscape shot. The bottom small picture contains a stronger mood, but it bears a slight quality of sweetness in its yellow and orange tones. The blue-violet tones in the large photograph have a mystical effect. The dramatic lighting effect is the result of using a graduated filter that darkened the uppermost sky. The camera was held very close to the water from a moving boat, which elongated the waves and gave the mountain its downward bow shape.

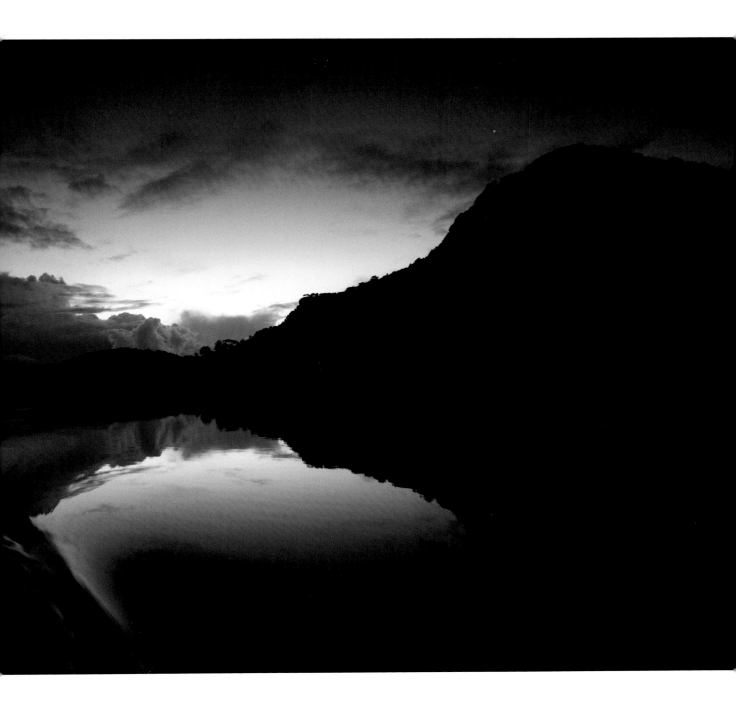

# 13

# Impression and Expression

External reality does not always draw us under its spell enough that we can fall into a state of concentration in which it is easy to shoot pictures that contain punctum. Some aspects of external reality leave more of a lasting impression on us than others. One thing is certain: a truly deep impression can only occur when we participate with reality directly, merge with it, and lose ourselves in the moment. The Buddhist Zen master, Dongshan, explains in his teachings the importance of hearing with your eyes and seeing with your ears. This is a typical paradox of Zen Buddhism. Applying these thoughts to photography means perceiving the surroundings with all your senses and your whole body, not just your eyes. Then your photograph will embody your full experience of the moment, including glimpses of color, wind, and even temperature.

It is a common refrain throughout the art world that you cannot achieve in art what you have not experienced in life. I agree with this statement completely and highly recommend that you consider it when creating your work. If you sense almost nothing, you will not succeed at creating works of photographic art. The deeper you can feel and perceive the world around you and your inner emotions, the more likely that the expression of those feelings will surface in your photography. That which has deeply moved you, that has completely penetrated your body and soul, will leave behind a deep impression.

Negative feelings, which are inescapable, also leave deep impressions on us. Perhaps it is these impressions that force an opposing expression. I consider the images of Edvard Munch or the films of Alfred Hitchcock and Orson Welles; I see these works of art as having come from a dark or negative place within the artist, and then transformed into expressions of great art.

The term "meditative photography" aligns itself, without a doubt, with positive expressions. However, it is essential to take a closer look into the dark part of yourself and find expressions for the negative impressions you've acquired throughout life; what we choose to express artistically corresponds with the aspects of our experiences that have left an impression on our souls. While the act of meditation is designed to free the mind from the bounds of language, sometimes words can be used to communicate impressions and expressions contained within an image. While meditation will help you understand your creative motivations on a sensory, emotional level, it's also important to be able to put these impressions into words after you've taken the photograph. These descriptions can explain particularly deep impressions and equally deep expressions to your audience.

These two photographs were taken on the Canary Island of La Palma. The photographs are of striking rock formations bearing characteristics true to their volcanic origin. In the long life of these rocks, the sea has formed them to their current (and constantly changing) shape. The sea has made a literal impression on these rock formations, and the rock formations express the movement and power of the sea.

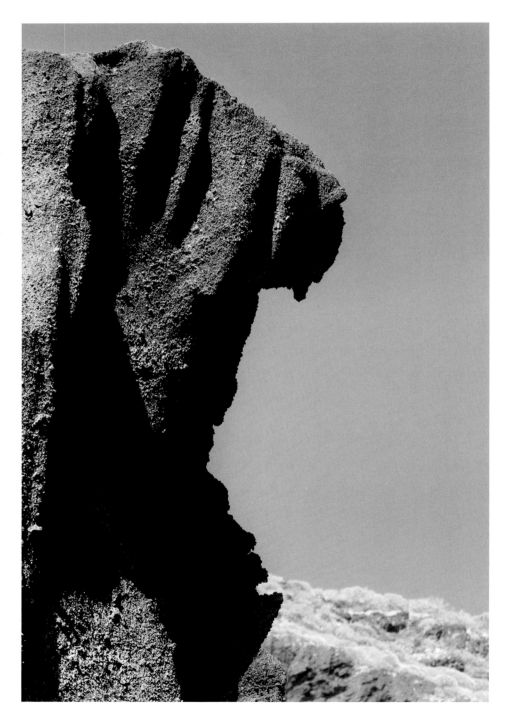

# 14

# What is Depth, or the Secret of the Night?

Even the word depth can be discussed philosophically. To look into the depths means to look down, maybe even into the depths of your own soul. In printing, depth refers to the darkness of tones, ranging from shades approaching black to those that are entirely black. The black tones in an image, especially in a black-and-white image, embody the darkness. An image that has many dark shades can have an effect that is mysterious, possibly even threatening. A look at the dark side of your soul can also be threatening. "Truly there is no wise man who does not know the dark which quietly and inescapably separates him from everything else." These lines are from Hermann Hesse's poem, "In the Fog." The artistic path to clarity leads through the darkness, otherwise that clarity has no depth.

The darkness of the soul can also be associated with the unconscious. In his 1924 manifesto, André Breton, a prominent Surrealist, expounded on his ideas about the unconscious mind, and how it is the source of all creativity. The unconscious mind influences our lives to a much greater extent than we think, and sometimes more than we would like. The unconscious mind expresses itself in the realm of our dreams. Similarly, the subconscious mind also influences our lives; we encounter it in the form of unpleasant emotions, such as anxiety or discomfort. If

you want to express the depth of the unconscious or subconscious mind through photography, you can incorporate mystery by featuring darkness. Darkness relates to the unconscious mind because it can distort reality, which can be threatening.

If you follow the path of meditation, it is important to look into your inner depth and bring what you experience out, "into the light." If you find your way into the mental stillness that Zen meditation refers to as "the still point," you have found the deepest source of all creativity. This source is deeper than the unconscious mind. It is free from all thoughts and ideas and is characterized only by the immediacy of reality. Images that are inspired by this deepest source will display a beauty that represents this depth. These images carry magic within their mystery. Herein lies the difference between images inspired by depth and those that only convey superficial beauty. We will consider this important difference in detail by observing the following series of night shots that hold more dark tones than light tones.

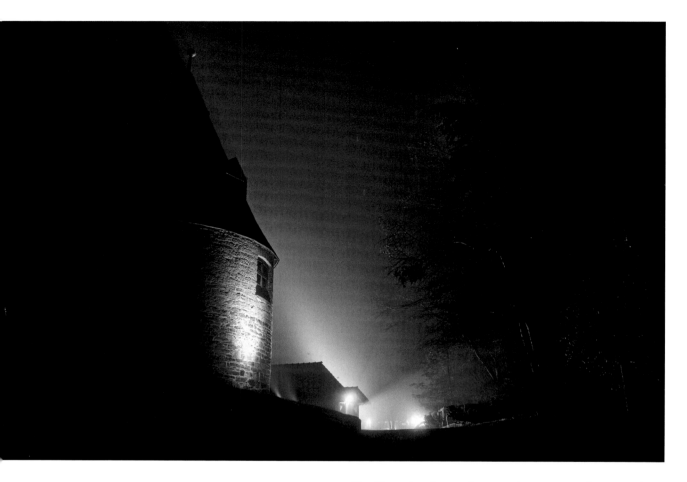

The November fog settling over the country makes most places seem mysterious. This is especially apparent when you illuminate objects in the fog, such as this medieval tower in Goslar, Germany. The glare of the spotlight spreads light into the murk. It is very important that the lighting remain constant during such a shot. To achieve the desired exposure, it can be helpful to use a bracketing technique and subsequently assemble the images using an HDR process (high dynamic range).

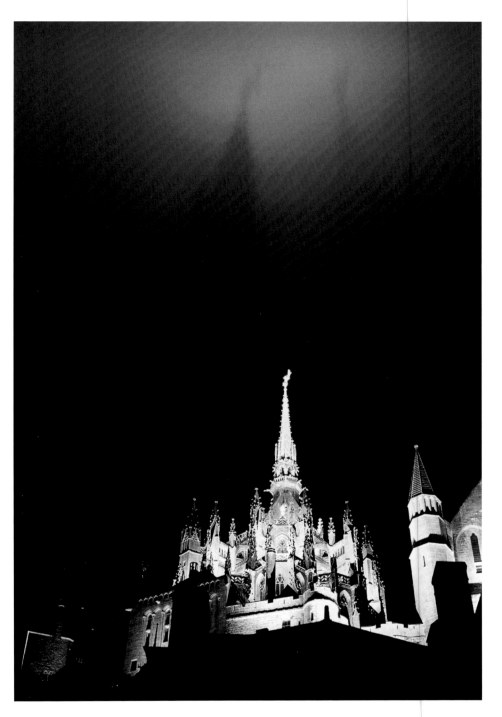

A cloud hangs low over Mont Saint-Michel in Brittany. The spotlights create a magical shadow in the sky. Without this shadow, the photograph wouldn't capture the mystical dimension.

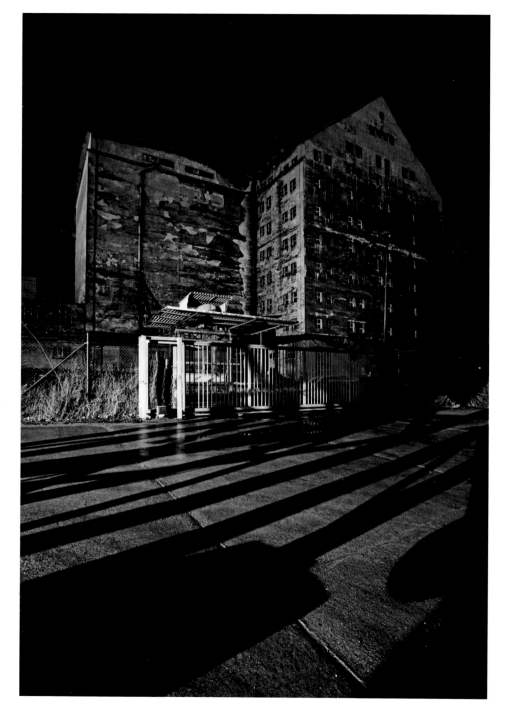

This scene has an alarming, almost spooky effect. An interesting play of light and shadow occur in front of this barricaded, run-down silo. The observer does not know the origin of the light source that creates the shadow effect. Abandoned buildings, especially at night, are generally perceived as eerie. At night, objects can appear threatening because the origin of shadows cannot be fully understood. In this image, the shadow is cast by a harmless steel-framed structure. This photograph was taken at a harbor in Brunswick, Germany, where nights are mostly quiet.

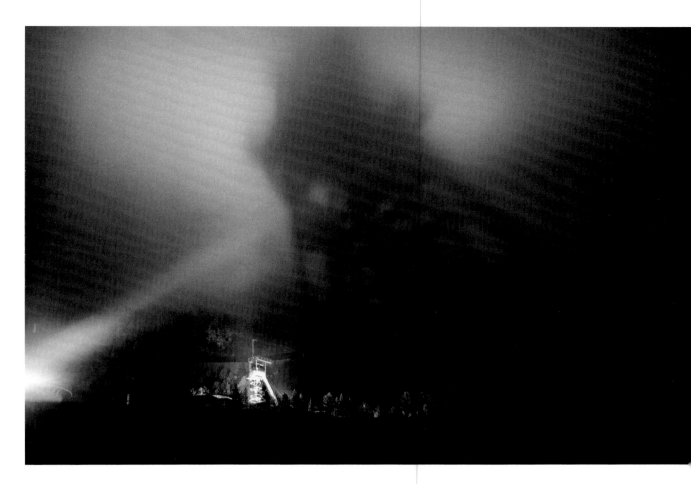

This picture has a misty mood. The shaft tower of a former underground mine near Goslar, Germany, in the Harz Mountains, is projected onto low-hanging clouds in the November sky. The projected image of the mining tower is about ten times as large as the actual structure, and rises like a magical phantom over the countryside.

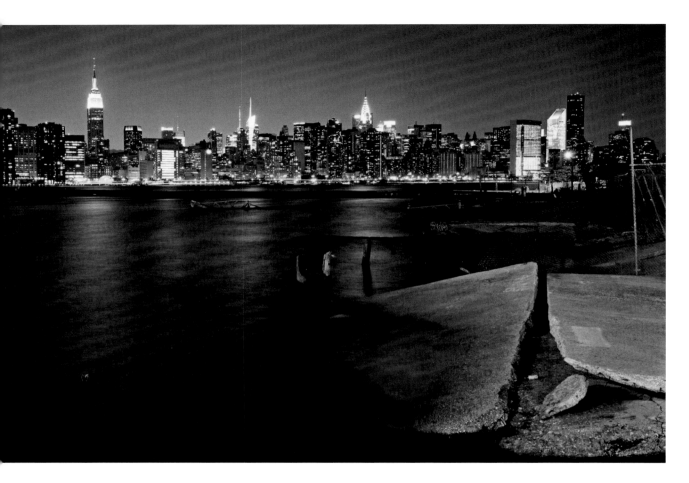

When photographed at night, it's possible to portray one of the busiest and largest cities in the world in a manner that conveys an impression of mysterious silence. In order to avoid the obligatory cliché photograph of New York City and the Brooklyn Bridge, I included crumbling concrete slabs in the foreground of the image area. By using this stylistic device, the skyline of Midtown, which has been photographed countless times, has a more unconventional edge.

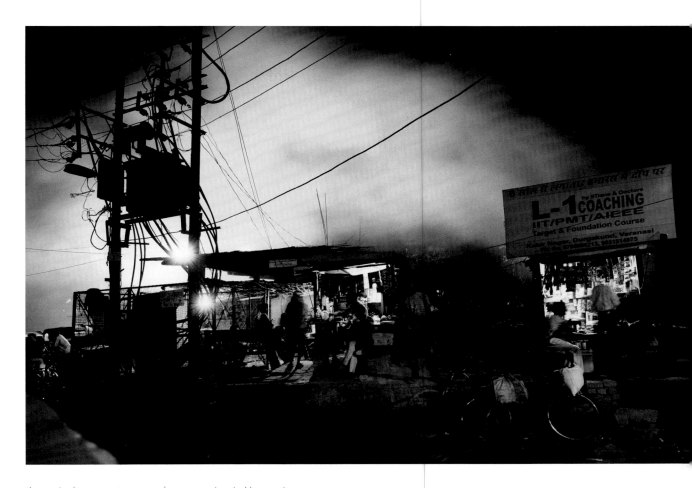

A magical moment occurred one evening in Varanasi, India. I was unprepared to take a night shot, but suddenly, smoke rose from a religious festival, which spectacularly illuminated the area I wanted to photograph. I didn't have the benefit of a tripod, so I set the camera on top of a stone wall where it could remain stable during the long exposure time as the shutter was released. The backlit power pole gives the photograph a very graphic effect, which helps the vibrancy of the scene.

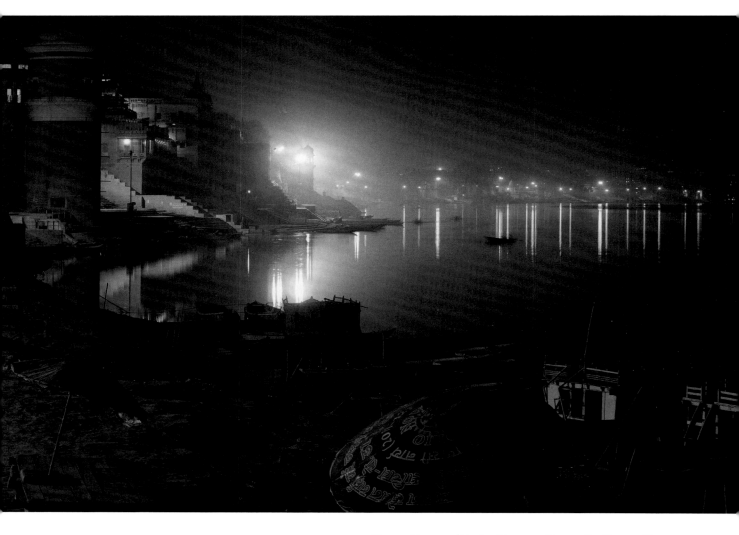

Varanasi is one of the best known cities on the Ganges River
in India. By night, it is one of the most mysterious and sinister
places in the world. In 2012, the old city walls had not yet
been replaced by modern ones. During the day, people wash
themselves and carry out their rituals in the river. At night,
the funeral pyres for the dead blaze as corpses are cremated.
Nowhere else in the world have I experienced life and death
so closely coincide as in Varanasi.

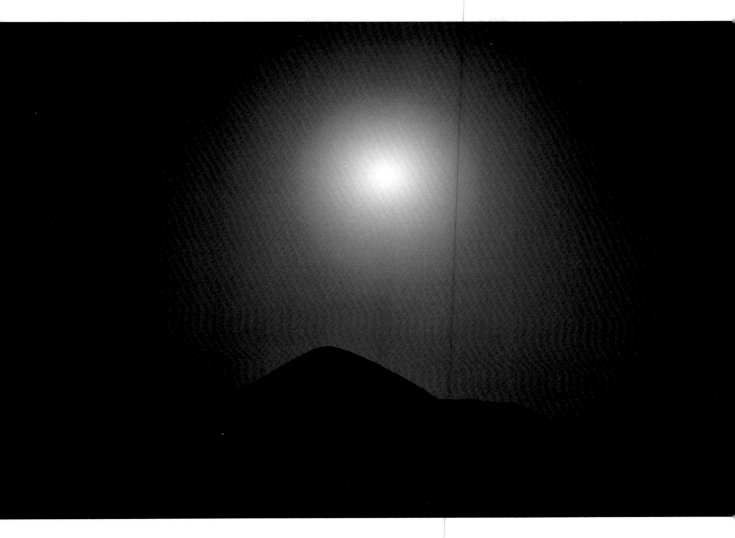

*This image, taken on the volcanic island of Lanzarote in Spain, is minimalistic. It shows only the moon and one of the many volcanoes on the island. The Calima, a hot desert wind, carries very fine sand dust through the air, which gives the night sky a hazy, murky appearance.*

# 15

# Inner and Outer Landscapes

In order to use photography as a powerful form of expression, it is especially important to find external aspects of your subject or scene that express your internal perception. It is helpful to find specific places in the external world that attract you. This does not mean travelling to a place because it is famous or has a significant history; on the contrary, go to places that you are interested in photographing, and then deeply contemplate why you are interested in that location. To experience more about yourself and your deepest feelings, put yourself into a relaxed state of mind and consider these questions: what kind of places cast their spell on you, and why are you interested in photographing them? Such magical destinations can be cities or more natural landscapes; they can also be less well known places, like a local cemetery, a backyard in the Turkish quarter of the city, a huge rubble pit on the outskirts of town, or mighty, ancient trees in a forest or a park.

Such a magical place for me was the Bronx in New York during the 1970s. At that time, the area was reminiscent of a doomsday scenario: entire districts were dominated by the presence of abandoned brick buildings that had been set on

"There is nothing worse than a sharp image of a fuzzy concept." | Ansel Adams

fire; their burnt out windows appeared as black holes. Many people sat on the side of the road drinking alcohol or using drugs. It was a very depressing sight. At the time, the images made a deep impression on me. Since the late 1990s, I have spent a lot of time in New York. Last year, for the first time in a long time, I once again visited the Bronx. I found a completely different place than I had previously visited. Although I took several busses crisscrossing the borough of the Bronx, I saw no run-down houses or abandoned buildings. That which I had associated with the Bronx for many years was gone. Therefore, the feelings that corresponded to my memories of the Bronx could no longer be expressed there.

"There is nothing worse than a sharp image of a fuzzy concept." This quote by Ansel Adams is the exact point: if you want to express the full range of your deepest feelings as a photographer, you have to be absolutely honest with yourself. You must search for destinations to photograph that you believe will allow you to express your innermost feelings. The ability to capture powerful images is a good opportunity to transfer your inner landscapes into your photography.

### Light or dark landscape?

*What kind of external landscapes resonate the most with you? Would it be the black volcanic landscapes of the Spanish Canary Island of Lanzarote, or the snowy peaks of the Himalayas? Both landscapes evoke very different associations and feelings. If we reflect on the volcano on Lanzarote, we might notice that it excites the vitality and primal energy in our core. Perhaps it is a metaphor for powerful feelings just under the surface.*

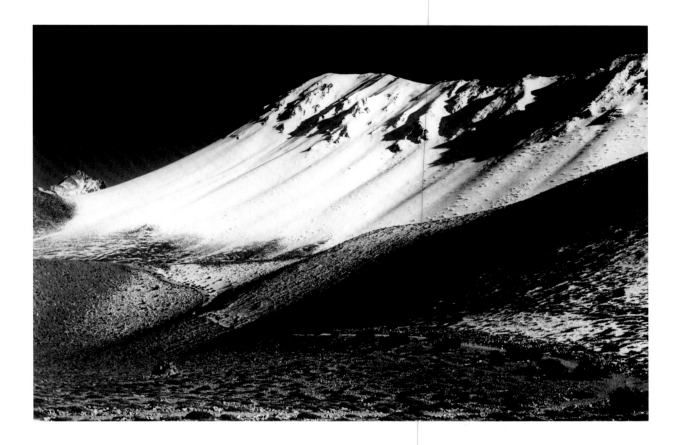

On the other hand, the image of a snow-covered mountain near Muktinath, a holy place of pilgrimage in the Himalayas, has a very different appearance. It is no wonder that these majestic mountains have long been considered sacred. They are referred to as "the seat of the gods," both in Hindu mythology and in Buddhism. In the Chinese I Ching (an ancient text), the mountain is regarded as a symbol of peace and strength. Naturally, this landscape bears a more luminous charisma than the volcano on Lanzarote, yet we must repeatedly ask ourselves why the mountain draws us to it, what kind of deep feelings does the landscape excite, and what counterparts in the external reality can we use to adequately express those feelings?

**Emptiness or fullness?**

*Are you attracted more to the desert or to lush tropical landscapes? The Sahara symbolizes the void in a landscape, whereas a fertile tropical landscape depicts fullness. Once again, we grasp the paradox of Zen as it emerges: when an emptiness of the mind is truly attained, a deeper fullness presents itself. Where do you find yourself on the path to fulfillment, and what kind of images can you take to accurately symbolize it?*

*The left image was taken near the Algerian oasis town of Timimoun. The right image was photographed in the country surrounding the large city of Bangalore, India.*

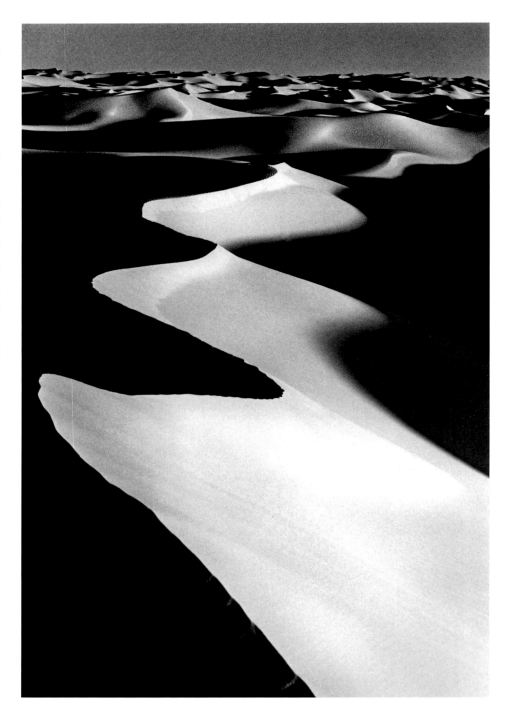

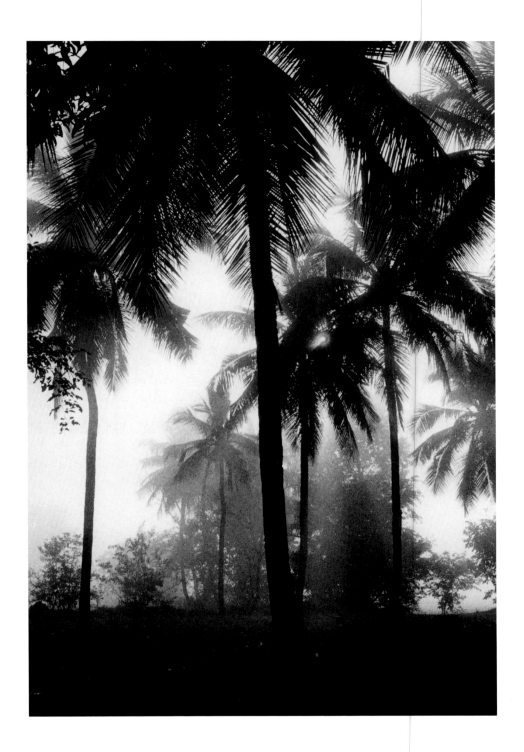

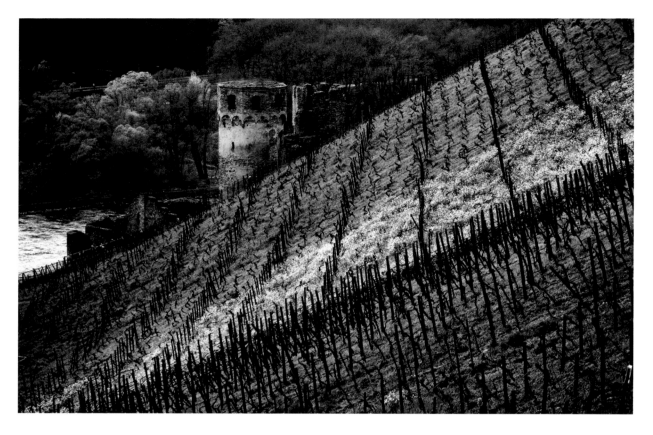

**Lovely landscape: gentle or dramatic?**

*Even a gentle landscape, such as this image from the Rhine River area of Germany, can stir very grounded, earthy feelings like joy, easiness, sadness, anger, or fear. These photographs show how the same scene can be photo-graphed in two different ways to emphasize peaceful or dramatic qualities. This photograph of the wine region with a castle in the background is gentle and demure.*

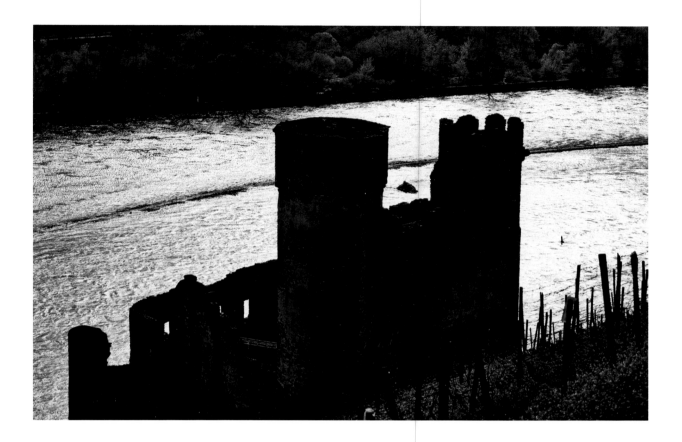

This second photograph, however, presents a more dramatic effect. While the picture on the left is composed of mainly soft gray tones, the picture on the right encompasses more pronounced light and dark tones. This is a result of backlighting the image, which produces a more powerful, dramatic mood.

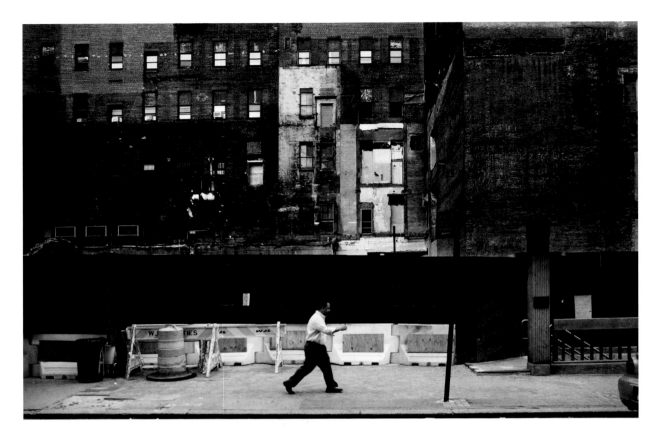

### Magnificent building or backyard?

*Cities offer a variety of locations where you can find physical representations for your perceptions. In New York, it doesn't need to be Manhattan or the Empire State Building. This backyard in Brooklyn created a rather gloomy, dark atmosphere in the photograph. The man is an important element of the photograph because he is positioned in the exact center of the composition, which builds, together with the lighter section of the building, an axis of symmetry.*

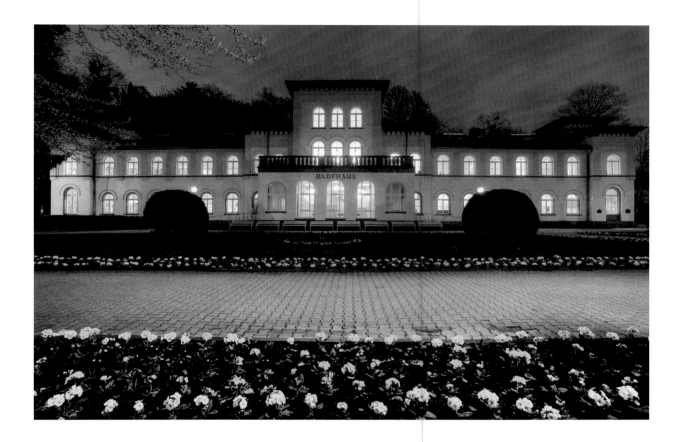

This impressive building is symmetrically divided. The image is of a former bathhouse in Bad Soden, Germany, near Frankfurt. This photograph broadcasts something quite different than the one previous. Because all the lights in the house were turned on, this neoclassical building appears alive with atmosphere. Which kind of urban landscape resonates more with you?

**Opposites in the
same city.**

*Completely dichoto-
mous worlds can be
found in almost every
major city. The city of
Palermo, Italy, is no
exception. The narrow,
often run-down streets
of this city allow you to
feel the mystery of time.
Here, chaos seems to
ooze out of the win-
dows. The image on the
right is of the beautiful
sculptures in the Piazza
Colonna in Palermo,
which is considered a
view-worthy attraction.
When presented in the
correct light, the image
has a slightly surreal
quality.*

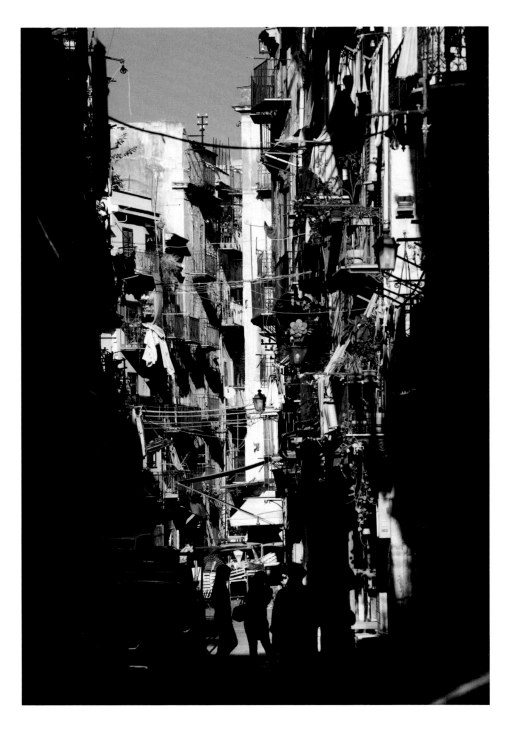

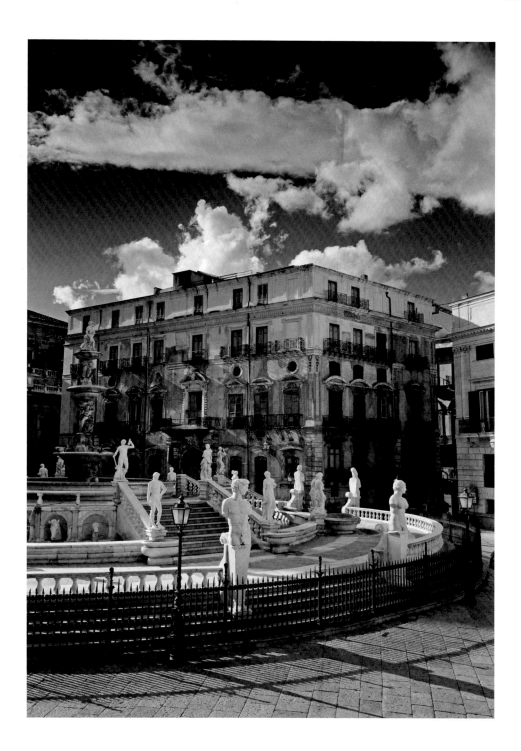

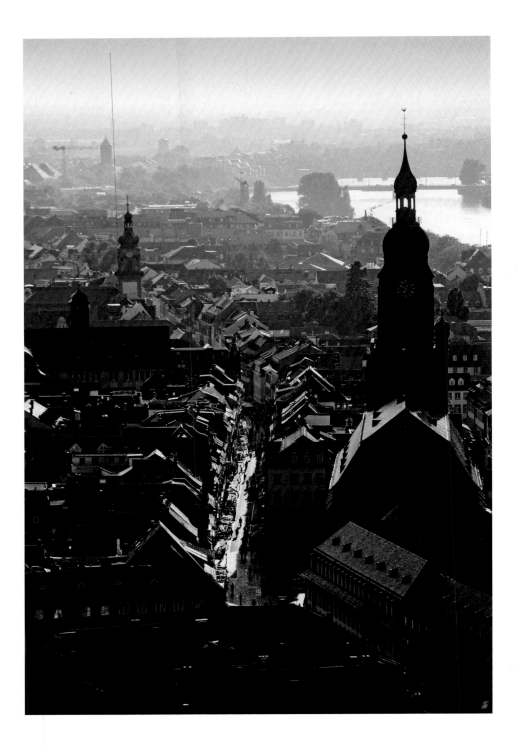

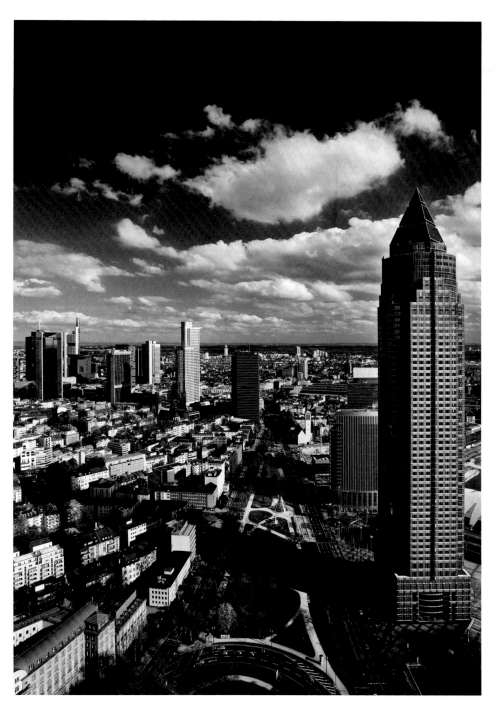

### Idyll or modern?

*What type of cityscape would best express your feelings in a photograph? The photograph of Heidelberg, Germany (left), expresses a mood of comfort, security, and warmth. The image of Frankfurt, Germany (right), with its more modern structures, portrays a rather sober mood of coldness and practicality. The bank towers in the photograph symbolize a feeling of power and strength.*

# 16

# The Alleged Objectivity of Photography

Photography is often considered an objective form of documentation, but it should also be considered a subjective expression of the photographer's personality. It is implied, I believe frivolously, that photography can be objective because it presents a moment as it occurred in a particular place at a particular time. Doesn't photography both reveal and conceal something important about the documented moment? For example, a photograph shows the scene in front of the photographer, but it cannot simultaneously reveal the scene behind the photographer. To illustrate this concept, I developed my series called "Janus Views." In this series, I took photographs, and then a companion photograph that shows the view that was behind my back when the first photograph was taken.

The color image of a sea-view (see picture on page 101) taken during a transfiguring twilight presents what you might presume to be an idyllic scene. The photograph objectively shows what appeared in the photographer's line of sight during that twilight moment. However, it also conceals what lies behind the back of the photographer: a sterile chain of buildings rising out of the ground in modern Dubai (see picture on page 100). By incorporating a "Janus View," the alleged objectivity of photography is quickly refuted.

Despite how hard one strives,
photography can never be objective,
and is therefore authentic.

In the last century, Bertold Brecht also made reference to this idea in his essay, "The Popular and the Realistic." He deliberated that it was almost dangerous to consider photography objective because this thought leads to deception. Brecht called upon photographers to use photography not to suggest the appearance of objectivity, but rather to be consciously committed to the subjectivity of the work.

Photographers Bernd and Hilla Becher were of the opinion that the photographer should stand as far back as possible when shooting an image so that the subject could speak for itself. In their photographs, they shot images with only gray light, and always from a central position for the purpose of allowing for objectivity in their images. Of course, the extensive work of the Bechers deserves recognition. However, it is astounding that the Becher style of photography has achieved such power in the photographic landscape based on its assertion that photography is objective. Some of their seemingly neutral images of old industrial buildings are no more objective than the images of Reinhart Wolf, whose photographs of industrial buildings are extremely atmospheric. Wolf's images are photographed using mostly iridescent sunlight. Unlike the Bechers, Reinhart Wolf did not claim to be taking objective photographs. Photography is not objective—it is authentic. With this in mind, I would like to encourage and guide readers to the tradition of conscious and subjective photography.

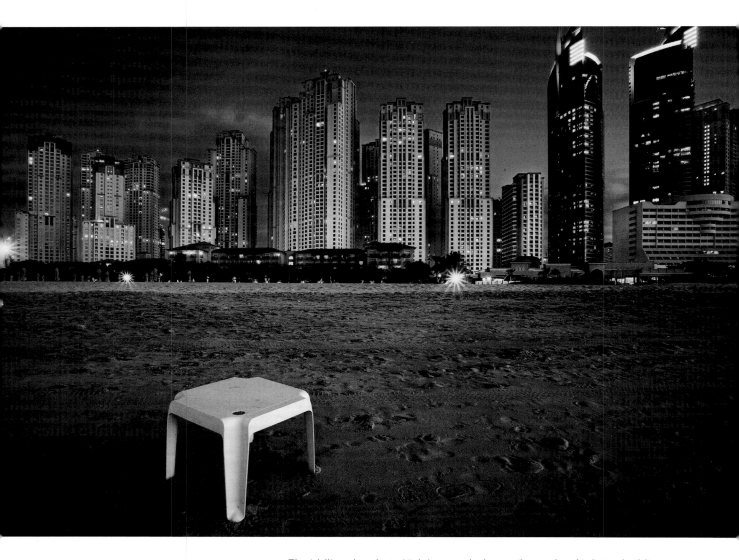

The idyllic color photo (right) conceals the sterile, modern high-rise buildings in Dubai that are positioned behind the photographer.

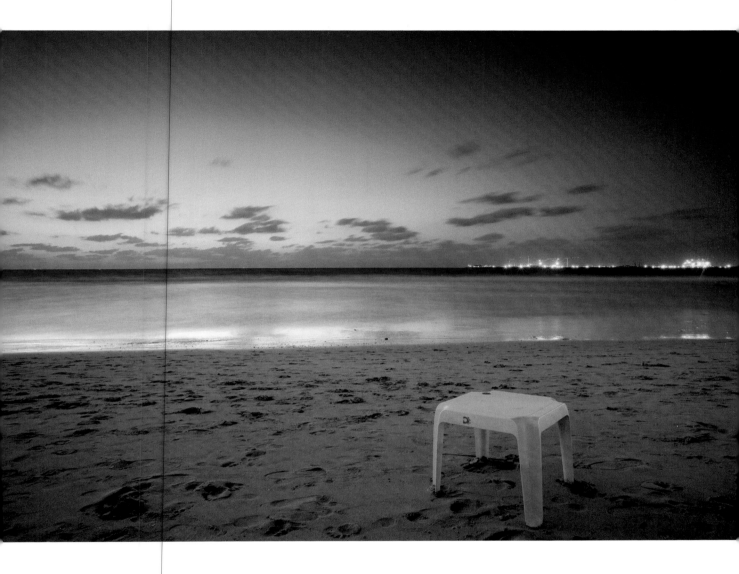

Again, the ugly and idyll are depicted in this "Janus View" perspective showing this image from two sides. The photo on the right of Okerauen in Brunswick, Germany, depicts an idyllic scene, whereas the reverse side of the coin is sobering.

The photo on the left shows the 650-foot high chimney in Brunswick that was erected during the early 1980s. It is so close to the city center that it dominates a skyline that would otherwise hold only magnificent silhouettes of church steeples.

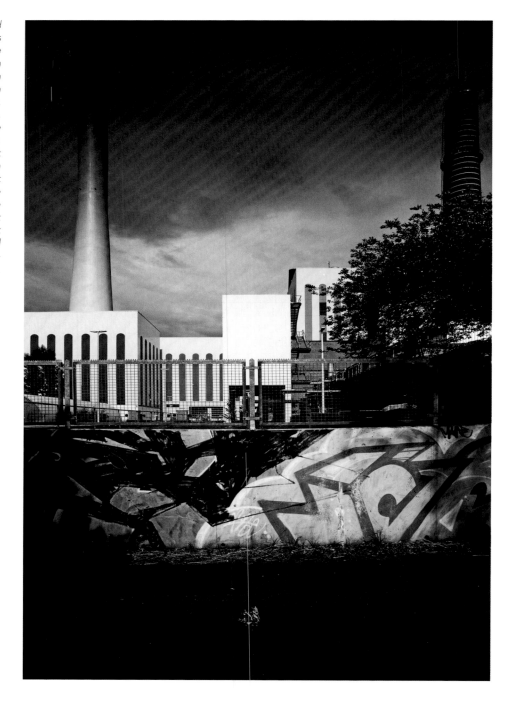

*These two photographs are another example of just how much a photograph can conceal. The left image shows a church tower on the Italian mountainside, with a line of cypress trees and a few old houses. This shot was taken with a focal length of 200mm. However, this idyllic image is a deception, as this wide-angle shot on the right illustrates. This photo of the same location was taken from the same vantage point at the same time. A huge warehouse and many greenhouses obscure the view of the landscape. Here again is an example of how much photography can distort reality based on the selectiveness of the photographer.*

# 17

# Basic Moods Expressed

The practice of Zen meditation is a way to silence the sea of emotions within, particularly negative emotions, so that your mind's surface becomes calm, and as smooth as a mirror. Photography is another way to consciously delve into and express your emotions. It can be a way to liberate yourself from negative emotions, as well as to emphasize the positive emotions. Using this practice in photography can result in powerful, authentic, and expressive photographs.

In Indian mythology, the various emotional moods are further divided into basic moods. The Navarasa are the nine basic moods of the soul. This concept also frequently occurs in music. In classic Indian music, it is common, for example, that a sitar composition would incorporate the nine basic emotional moods. The Navarasa are:

1. Shringara: love, eroticism, tenderness
2. Hasya: playfulness, laughter, exuberance
3. Karuna: grief, worry, compassion (or empathy)
4. Raudra: anger, irritation
5. Vira: courage, energy
6. Bhayanaka: fear, fright
7. Bibhatsa: hate, resentment, horror
8. Adbhuta: wonder, magic, magnificence
9. Shanta: peace, calm, spiritual awakening

Meditation also means self-confrontation of the entire spectrum of one's moods.

As photographers, we need to find corresponding external counterparts in reality for our internal moods. What are your prevailing basic moods? Using photography, how can you express yourself and these states of being? What external counterparts that represent your moods occur to you? If you are so inclined, take a little time to reflect on this. Better yet, meditate. Remember to be honest with yourself!

## The Dark Side of the Soul

Meditation also means confrontation with yourself. You cannot escape the emotions inside you that appear in your mind's eye. You can observe these emotions and allow them to pass by at a distance, but they can't be easily eliminated. Once you begin to meditate, things you thought you had long forgotten and overcome might surface in the calmness. These thoughts are also important to contemplate. During meditation, we gain insight into our subconscious mind, which includes the dark part of our soul. There are four moods from the dark side of the emotional spectrum included in the Navarasa.

Moods can be transformed into images using the medium of photography. I've selected six of the nine basic moods three "dark" and three "light," to illustrate this concept with examples of how to find underlying moods in corresponding

external objects or scenes, and how, through the help of photography, you can translate these moods into images.

### Karuna (sadness, worry)

How are counterparts that correspond with these moods of the soul found in the external reality? Sadness and concern can be captured when photographing people who embody the emotion in an authentic way. Karuna, however, may not express itself in such a strong form. It is a mood of sadness and worry, but can also be a mood of profound, perhaps poetic melancholy. This is a mood that is often expressed in a variety of different types of art and music.

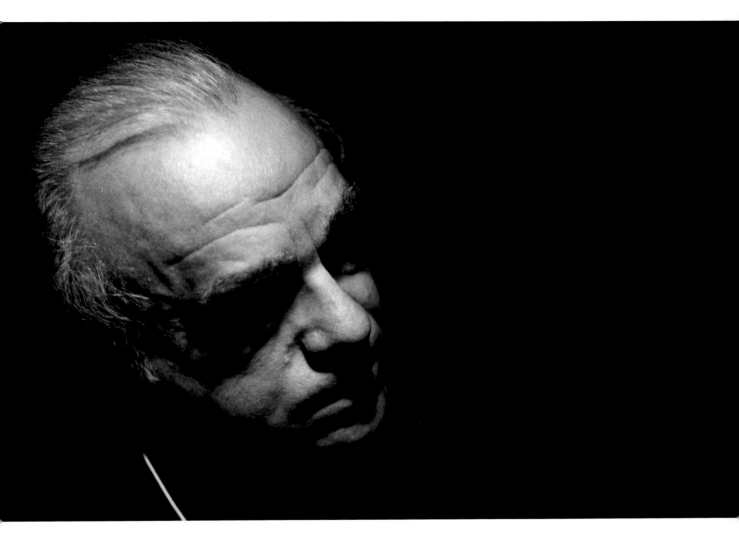

This is a photograph of a man whose wife had just died from cancer; his face reflects tremendous grief. I reinforced these emotions with photographic composition. I photographed the man from above and used only one overhead light for illumination. This produced the effect of his eyes and surroundings disappearing into darkness. At the time this photograph was taken, the darkest night ruled in the soul of this man.

This photograph was taken through a rain-covered windshield in a parking lot in the Netherlands. Raindrops seem to merge with the background images. The rainy, slightly fogged window no longer allows a clear view of the reality beyond. Perhaps it is a group of trees, but it is unclear.

Photos like this recall how our strong emotions sometimes distort our view of reality. Therefore, it is important to find distance from our feelings while meditating. Photography, however, is just the opposite. One should capture feelings as powerfully as possible to have the greatest impact.

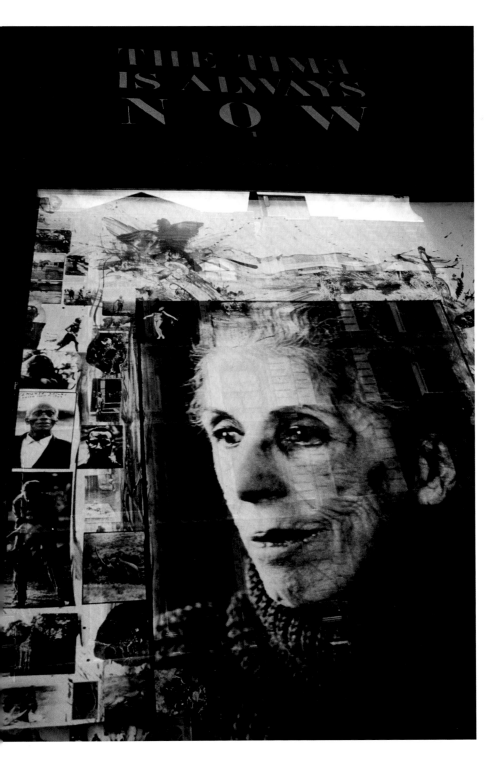

This photograph invites us to regard melancholy philosophically. The image shows a view of a picture window in which a large photograph of an aging face is surrounded by many small, partially concealed photographs. The images appear to be representative of memories. The words "The time is always now" are written over the window containing the compilation of enigmatic photographs. You can imagine that this person pictured in the large window is contemplating the past. The text reminds us of a past that no longer exists. The only reality is the present moment. There is strong melancholy in the realization that there is nothing you can hold onto in life. Every moment quickly becomes part of the past. A keepsake photograph will never hold the same qualities as the actual moment that it represents. Photography is more than taking keepsake photos; it is about producing powerful photographs that renew the past moment and bring the viewer into that present. Such photographs contain an element of mystery—they suggest a moment that no longer exists and can only be accessed through the view of the person examining it in the current moment.

## Bhayanaka (fear, terror)

Which of us mere mortals is completely free from fear? Fear springs from an emotional place in our psyche rather than a logical state-of-mind. It is more an emotion than a thought. Over time, the path of meditation will allow you to empty your mind of the clenching anxiety produced by fear, but will not bring immediate relief. In art, however, fear can be a very powerful subject. For example, Alfred Hitchcock is certainly a filmmaker who mastered the art of using imagery to generate convincing feelings of fear or being threatened. Cheap horror films create fear using stylistic devices like gore and action-heavy chase scenes. Hitchcock succeeded at the highest level by portraying thrilling psychological terror and imparting those feelings to the viewer.

*Bhayanaka is portrayed in this image of a man who embodies fear and anxiety. I met this farmer a long time ago while I was on a trip through the western part of the USA. He lived all alone in a huge farmhouse in New Mexico. His loneliness and anxiety were palpable. His distinct body language—his closed body stance and his uneasy facial expression—spoke volumes about his state of mind. This man had lived a hard life and clung to a rigid Christian lifestyle. At that time and place, extremely fundamentalist churches were increasing in popularity. The foundation of these conservative churches is entirely different than the foundations of Zen meditation, which is about recognizing and freeing yourself from internalized dogma and beliefs. The path of meditation leads us to a deep reality beyond verbal comprehension and dogma; it is a path that can free us from fears and limitations. The path of photography offers ways to use images of our fears as a form of artistic expression.*

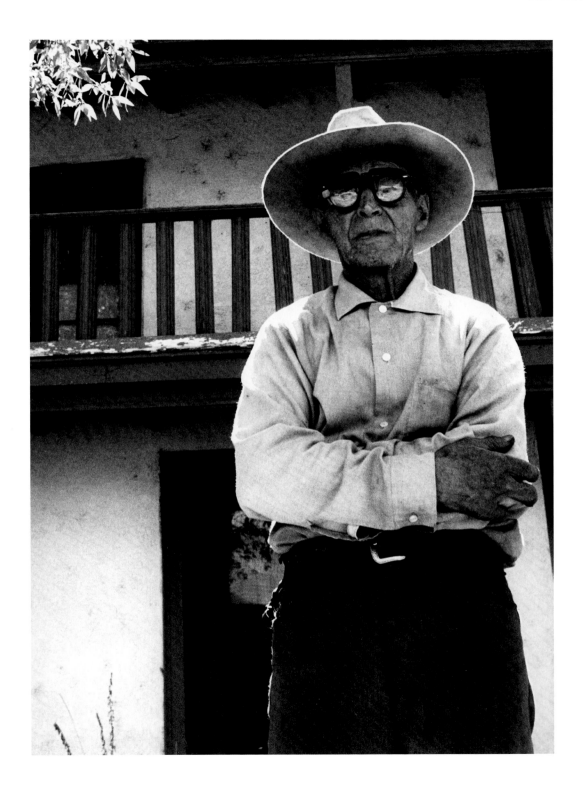

*Using various stylistic devices in photography, you can capture the mood of fear or impending threat in images. When combining shades of black with relatively little light, photographs give a threatening impression. In this photograph, taken in Goslar, Germany, the viewer looks into a narrow alley completely surrounded by darkness. The observer encounters a person in the image that he will inevitably meet. Such situations trigger an instinctive feeling of caution and heightened awareness, which can manifest as fear.*

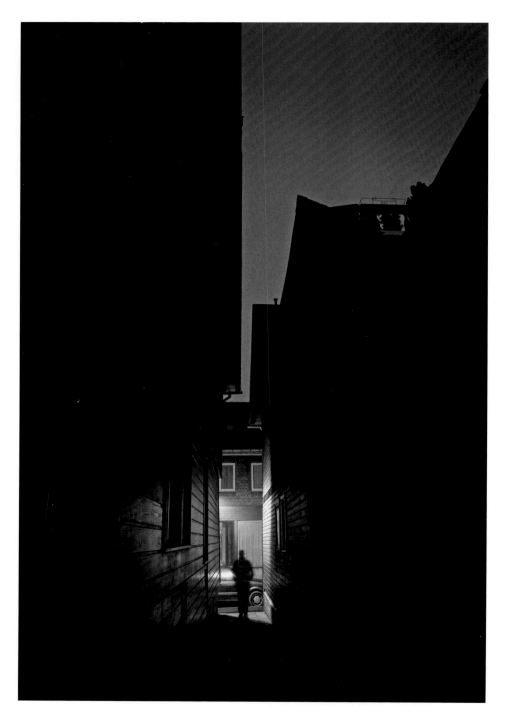

This photograph of a New York backyard shows a relatively narrow chasm of light between two high walls. A chimney stack is silhouetted in the light. The combination of the use of black, a narrow opening of light, and a dark chimney stack is capable of producing a threatening feeling. Both of the preceding photographs could be scenes from a Hitchcock movie.

This photograph and the picture on the opposite page flirt with the feeling of fear and potential danger. A hooded figure lurks along a wall. A foggy, night mood prevails. The figure is in a strange position and gives the impression that he is carefully making his way, as if he fears someone might ambush him. This scene creates a scary impression, but in reality holds a harmless explanation. It was Halloween and this man was merely dressed for the occasion and wore a mask. There was no reason to position the masked man largely as a focal point in the composition, because he would have been out of scale. Underplaying his size keeps his presence relatively subtle in the background.

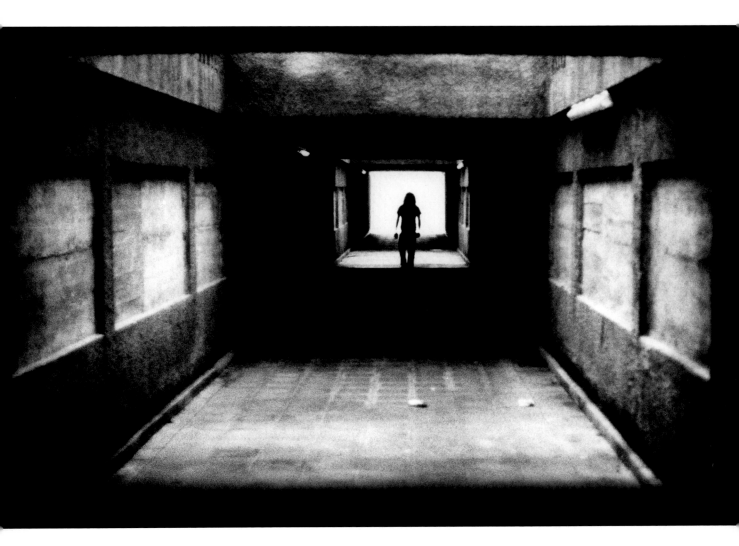

This image symbolizes confinement and captivity, but also demonstrates the proverbial idea of light at the end of the tunnel. It reminds us once again that all mental states, moods, and feelings are temporary.

Bibhatsa (hate, resentment, horror)

This is certainly the cruelest of all mental states of being. It is the cause of wars, murders, and violence. Everyone at one point in his or her life has had a sensation of what it means to experience anger or hatred. You should avoid probing too deeply into these feelings. It is possible to attempt to express such feelings, and thus gain distance from them, through photography. It is relatively easy to portray these feelings through images of war. Well-known American photojournalist James Nachtwey experienced great success with this photographic genre.

The event that I experienced through the media that moved me the most was the terrorist attack on the World Trade Center on September 11, 2001. The most terrible feeling of hate was prevalent in this act of terror. One reason the attack had such a profound impact on me was because I had recently visited New York, a city that I love very much. Since I do not think much of cruel, sensational photography, I tried in a quiet way to express the events of September 11 through my photography. During my stay in New York in June, 2001, I admittedly took far too many shots of the World Trade Center for my upcoming New York calendar. When the atrocious terror attack on New York occurred, I immediately made the decision to return to the site of the twin towers and replicate the images I'd taken previously from identical perspectives and angles. These photographs held no images of the twin towers. The absence of their presence subtly illustrated this feeling of hatred and horror.

This less than subtle portrayal of Ground Zero was taken approximately one month after the brutal attack. This photograph depicts the horror of destruction and the deeper underlying hatred against the United States.

The following two images were taken from exactly the same vantage point, at the same angle. The second photograph was taken in October, one month after the September 11 attack. Not only had New York completely changed, the whole world became a different place after these attacks.

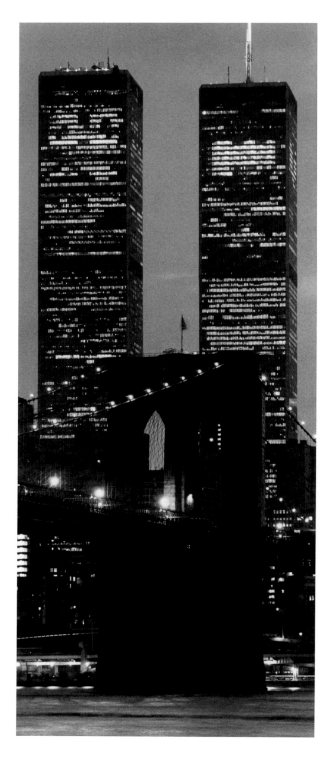

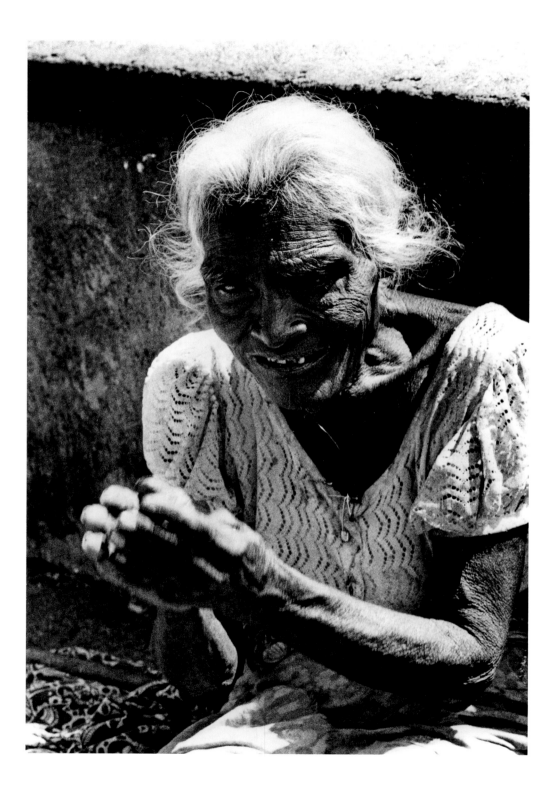

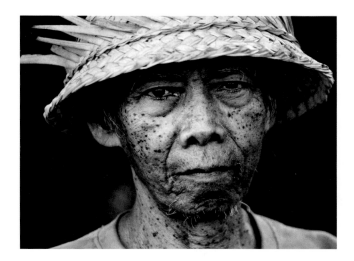

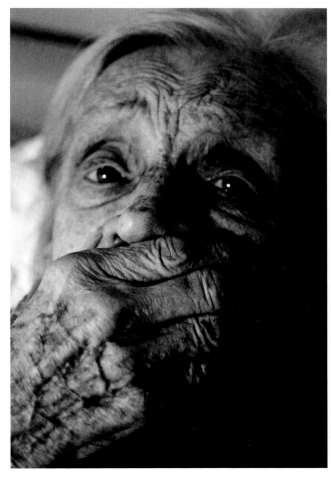

*Legend has it that when Buddha first came out of his palace, he saw poverty, sickness, old age, and death. He then understood that life is characterized by these conditions. These life events also present themselves in photography. The first image is of an old beggar in poverty-stricken modern India. The second image is of an Indonesian rice farmer whose face shows telltale signs of age and the effects of physical labor. The third image is an old woman who suffered from severe dementia and lost her memory shortly before her death.*

## The Light Side of the Soul

The Zen philosophy of meditation, along with other forms of meditation, seeks to help people overcome the dark moods of their soul. For advanced practitioners of meditation, it is possible to experience stillness in the mind and inner emotional balance. If you exist fully in the moment outside of a meditation practice, the beliefs of Zen allow no room for negative emotions. Of course, things do not always unfold for us the way we might hope or the way it is intended in the ideal world of Zen. For this reason, I suggest using photography as a means of expressing the emotions that cannot be balanced via meditation. Both positive and negative emotions can be wonderfully expressed, but beware: positive emotions as expressed through photography run the risk of appearing kitschy. To express authentic emotions, it is important to avoid allowing anything that isn't meaningful to enter the image area. In photography, kitschy refers to something so simplified, clichéd, and romanticized, that it is far from the truth. Positive feelings can, however, be created in photographs without appearing tacky or too sentimental. Using the idea of the Navarasa, the following examples are of three positive basic moods.

## Shringara (love, eroticism, tenderness)

This is the stuff on which many novels and movies are based. What would life be without love? Without a doubt it would be extremely boring! In some great literary works, such as Goethe's *Faust*, Shakespeare's *Othello*, or Hesse's *Siddhartha*, love is the pitfall that snares the protagonist into plunging deeply into the abyss. Buddhism offers some considerations on the subject when love is confused with sexual desire. Desire is considered a vice because it can become an addiction. Buddhism actually regards passion as negative. Buddhism teaches liberation through the elimination of attachment. He who follows his desire or passion loses a piece of his freedom because he is controlled by it; Buddhism views this as a kind of compulsion. Buddhism follows the idea of detaching from desire. Some people find the logic of this concept difficult or faulty; are not people, who have never been ensnared in the perplexity of passion, a bit uninteresting?

In the spirit of Buddhism, it is important not to confuse love with sexual desire. Love is, above all, compassion toward others. Compassion is even more pronounced in Tibetan Buddhism than in Zen Buddhism. The philosophy of love could fill pages and those who have not experienced love in their lives are certainly unfortunate. The following images are examples of this kind of love in photography.

This photograph can be an expression of romantic love in a romantic place, as long as one identifies a backlit New York City, early in the evening, as romantic. This image was taken using film, and would be difficult to capture digitally given this kind of lighting situation, because a large image area gets lost in the light of the sun. The image can be improved with the help of underexposure and graduated filters.

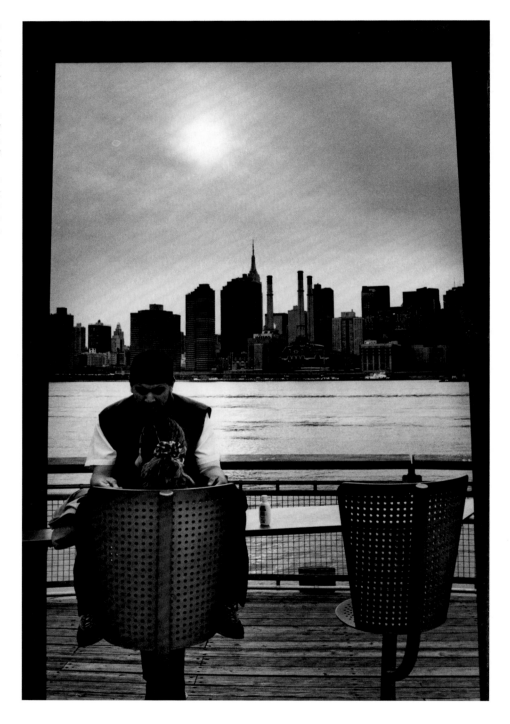

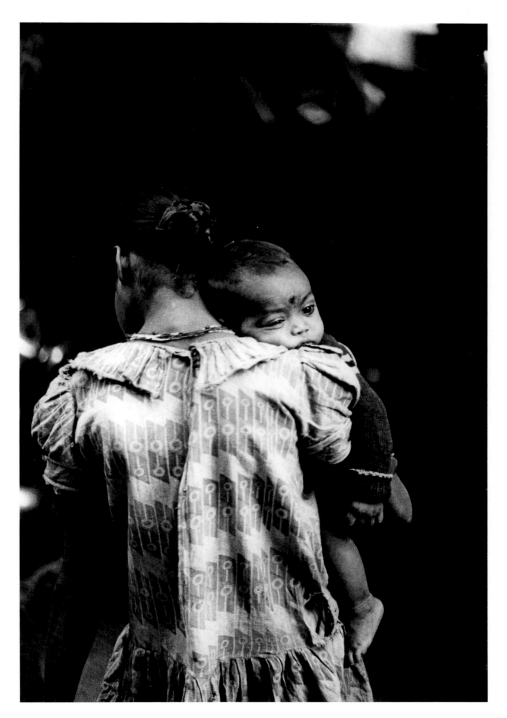

A different kind of love is a mother's love for her children. This is one of humanity's basic instincts and provides primal trust. This photograph was taken in Calcutta, India (today Kolkata) and has a tendency toward sweetness without appearing tacky.

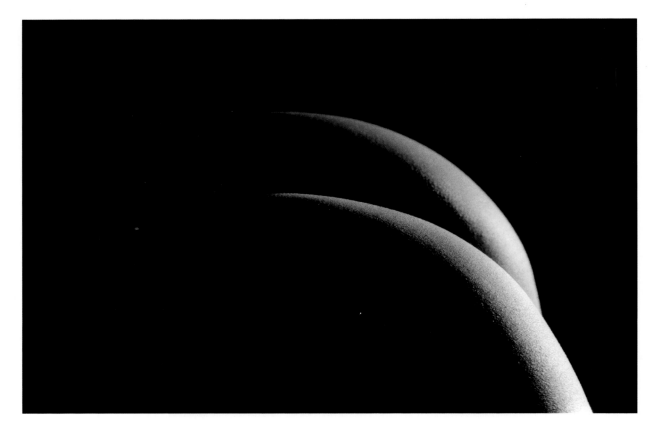

*The representation of eroticism should be used discreetly. German pho-
tographer Helmut Newton had an apposing aesthetic. His images were
often of naked women unemotionally illuminated. Eroticism conveys more,
in my opinion, when a part of the body remains veiled or in the dark. This
way, a piece of mystery remains in the image.*

*This image prompts questions because it exists as an excerpt. Only one eye is in focus; the left side of the face is blurred. The rudimentary form of the nose is recognizable as it emerges from this blur. The eye is piercingly sharp, while the hand on the right moves into the blur. The picture embodies certain poetry: the eye betrays an element of anxiety and melancholy. The woman places her own hand on her mouth while another hand touches her face. What is the lingering story in this minimal excerpt? This photo expresses tenderness, an essential form of love. Again, the image doesn't exceed the limits of being too sweet.*

Adbhuta (wonder, magic, magnificence)

These basic elemental feelings are very important requirements for a good photograph. If you take all the beauty and greatness in the world for granted and can no longer find your way to a state of emotional wonder, it is difficult to produce good photography. Adbhuta is the emotion that makes it possible to see things with wonder, as though you are seeing them for the first time. The ability to achieve these emotions allows you to express the big and small things in life through photography.

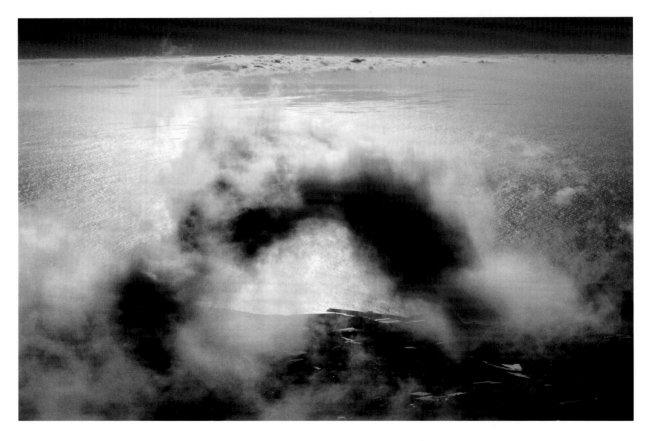

*Rising clouds in continual transformation are a breathtaking representation of the magnificence of nature. This image was taken 6,000 feet above sea level on the island of La Palma in the Canary Islands.*

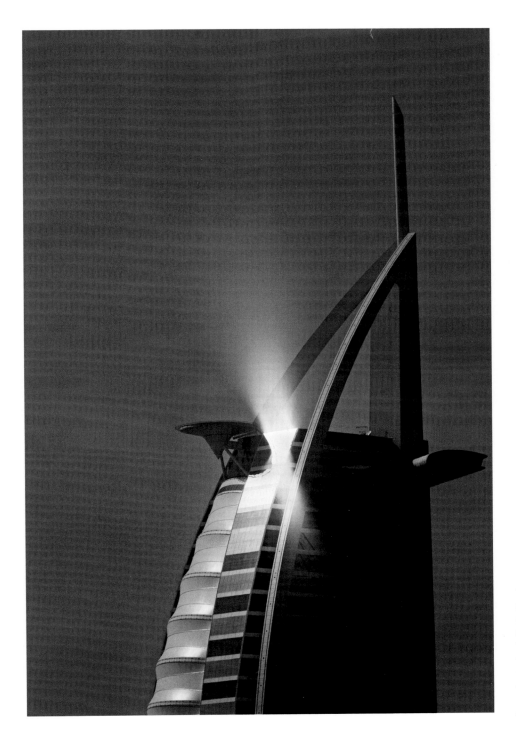

The Burj al Arab Hotel
in Dubai is probably one
of the most impressive
buildings in modern archi-
tecture. The reflection
of the sun, with its rays
escaping softly into a hazy
sky, produces a particu-
larly magical effect in this
photograph.

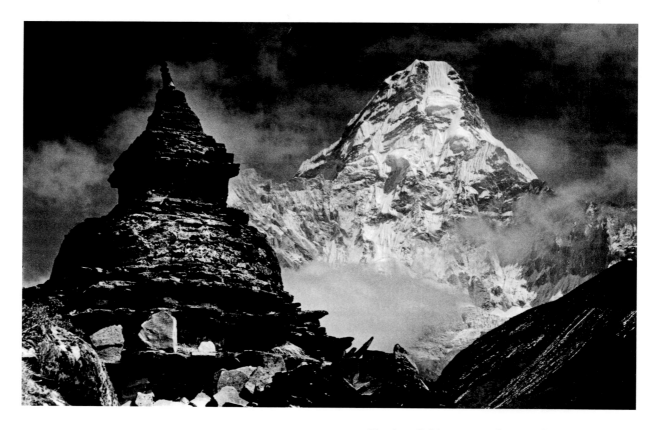

The Ama Dablam in Nepal is one of the most beautiful mountains of the Himalayas. The Buddhist Stupa (mound-shaped place for Buddhist meditation) in the foreground corresponds to the shape of the mountain. To create a depth of field between the two elements, the aperture had to be set to 22 with a focal length of 100mm. The use of a tripod was necessary because of the long exposure time. The intricate photographic process, however, could not diminish the enthusiasm created by this sublime sight.

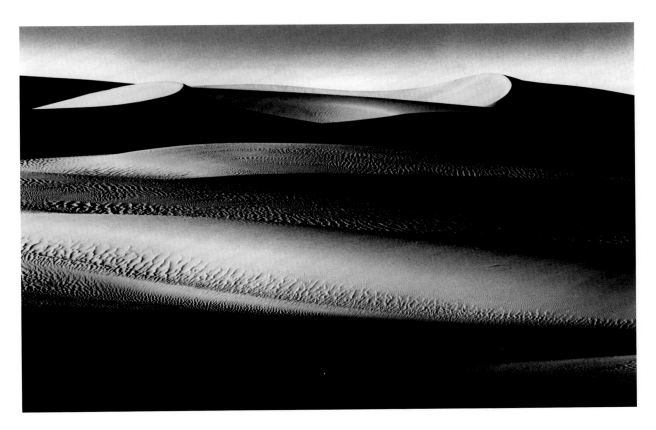

*Photographs should be taken in the early morning or late at night in the Algerian Sahara in order to see the special magic of light and shadows on the landscape. After travelling for a week with a travel company, I ventured out on my own. The creative process of photography was incompatible with the needs of an organized travel group.*

### Shanta (peace, calm, spiritual awakening)
This is most certainly the highest of all prevailing moods. It is the basic mood of deep peace and calm selflessness. This is a mood in which photography is not required for relinquishing thoughts and existing as one with the world. However, such a mood can be expressed by symbolism in images.

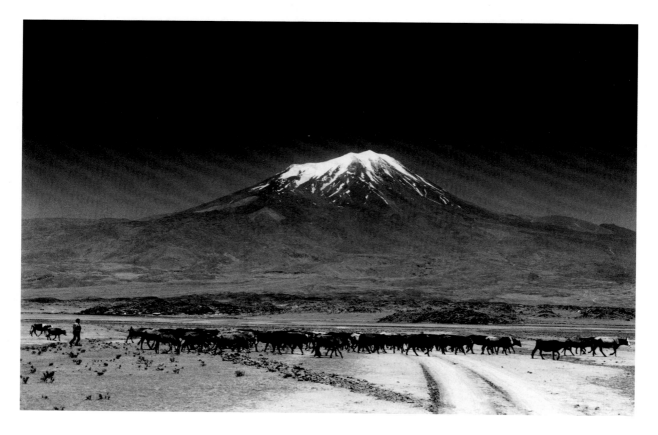

*Mount Ararat is over 16,000 feet tall, the tallest mountain in Turkey. It is shrouded in legend. It is considered the place where Noah's Ark was stranded during the Biblical flood. How do you photograph this legendary place when the light is at your back, preventing light and shadow detail in the contours of the mountain? In this instance, a herd of cows and shepherds came to the rescue; they created some detail to make the mountain stand out, and hinted at a symbolic peaceful unity of man and nature.*

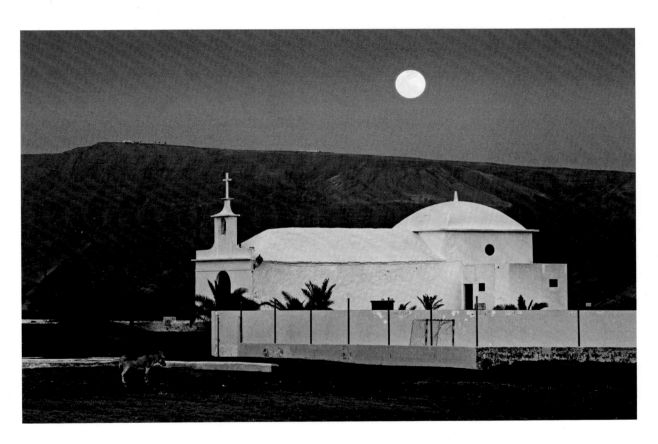

*A deep calm radiates from this scene: a donkey, palm trees, a whitewashed church, barren mountains, and a full moon exude stillness and peace, without being shallow or kitschy. Positive sensory images run the risk of being cliché or tacky. This tends to occur more frequently in color photography, especially with sky images that feature heavy use of orange and red tones. This photo of a chapel on the island of Lanzarote was taken at dusk (the blue hour) using a powerful telephoto lens. The dynamic range of the sensor was sufficient to allow the full moon to be captured in the picture. The sensor could not have accomplished this in the darkness of a moonless night.*

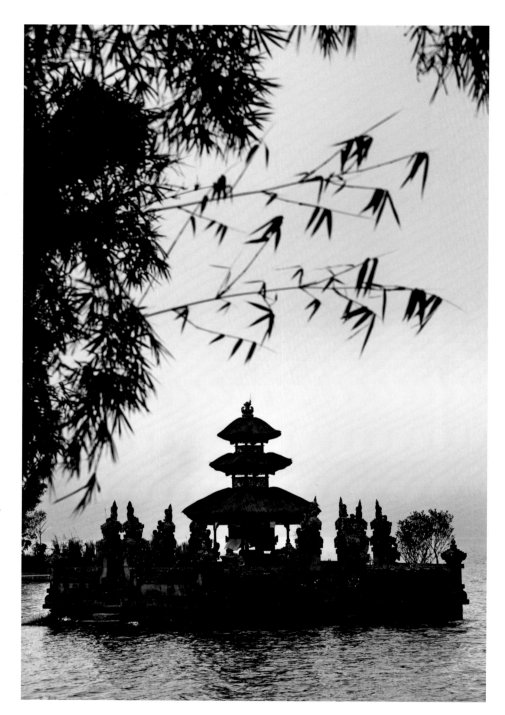

This pagoda temple on the island of Bali exudes the unity of man-made architecture and the surrounding nature: a unity that has often been lost in modern times. The bamboo branches above the temple are reminiscent of an Eastern-style ink drawing. One can well imagine why people retreat to such a place to come closer to the Divine.

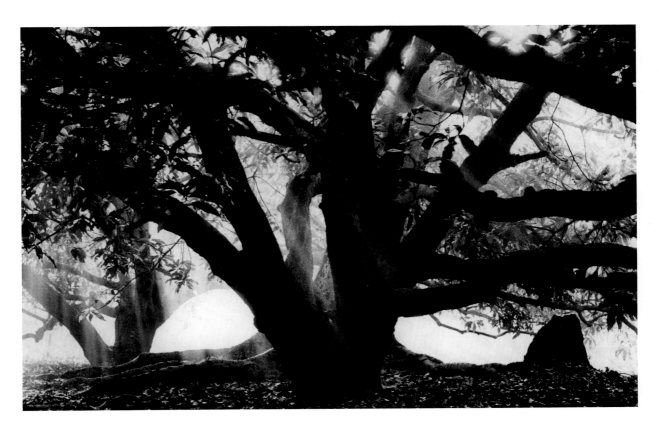

*Early morning rays of sunshine awaken the day. This is an especially peaceful image that undoubtedly arouses a positive mood in the observer without appearing cliché or kitschy. The pictured was taken on the outskirts of a small Indian village near the city of Bangalore.*

# 18

# Representing Beauty without Being Shallow

Those who do not have much experience with photography are generally happy when they view photographs of beautiful subjects, such as of a stunning sunset or colorful flowers. If you have devoted yourself intensively over a long time to the art of photography, these types of images may no longer bring you artistic satisfaction. Why is this? One explanation is that sunrises or sunsets are truly magnificent sights: any photo taken would pale in comparison. Because of this, photographs of sunsets or pretty flowers leave a somewhat shallow impression on the viewer.

Another explanation is the artistic quality of the image. The difference between an ordinary photograph and a really good photograph can be likened to the difference between an image for sale at a retail store and a landscape painting of Rembrandt or Ruisdael. A painting sold in a retail store is less likely to have depth. (The meaning of "depth" was discussed in a previous chapter, "Impression and Expression.") These images, which are often mass-produced, often lack inspiration from a truly creative source. While technically adequate, these images usually lack the certain essence of something that touches the viewer and produces a larger impact than being "pretty" or being "nice." In previous chapters I described that extra element using Roland Barthe's concept of punctum. Perhaps the difference can be understood when comparing two kinds of beauty: that of a fashion model, whose face and body have been cosmetically

To see and portray true beauty is to
seek and find the true nature of things.

transformed to conform to the current societal standards of beauty compared to the authentic beauty that shines from within an old man with a hooked nose.

Photographs of flowers, sunrises, and sunsets don't often bear evidence of a serious confrontation between the creative mind and the subjects. It is often simply a cliché, a shallow reproduction of what is generally perceived as beautiful. The well-known German photographer, Karl Blossfeldt, is a good example of how beauty can be observed and photographed from a unique perspective. Blossfeldt created a personal visual language to photograph plants. Using black-and-white photography, he portrayed them emphasizing their intrinsic architectural structure. The resulting images are anything but shallow.

Of course, we all love the idyll. Perhaps the idyll often appears shallow because it is almost always a false pretense of reality. When you look a little more closely at the world, you will notice that each idyll has fractures. When you look within, even people who want to appear whole have shadows and cracks in the depths of their lives. The essence of a good novel is to identify and play upon fractures and weaknesses in the characters.

Examining the following images, let us try to identify the difference between shallow photography and images that contain that unique depth.

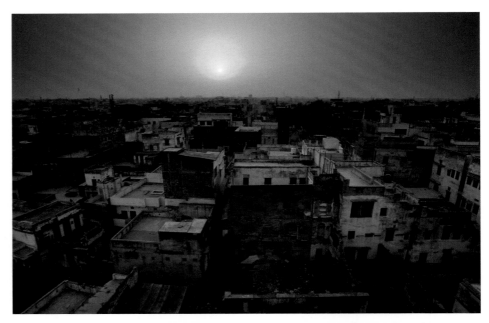

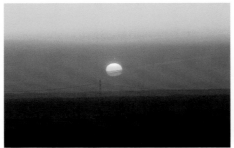
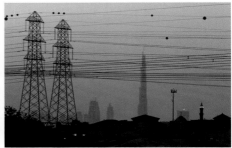

The small photograph on the bottom left depicts a kitschy sunset that is in no way original or unique. Such images are photographed daily by a multitude of amateurs. For the discerning viewer, these types of photographs are cliché. With his mass-produced Mona Lisa, Andy Warhol demonstrated just how quickly an image could lose its power when it becomes a mass phenomenon. A sunrise or sunset is very difficult to portray in a way that isn't shallow; one way to avoid the problem is to not include the sun within the image area. An image of a sunrise or sunset containing a sky imprinted with orange tones can easily border on being tacky. The small picture on the bottom right avoids this pitfall because the subject itself is the sun. The image is of high voltage overhead power lines and the Burj Khalifa in Dubai. The resulting image is of a romantic modern metropolis rather than a trite sunset.

In very rare cases, a basic sunset can produce a desirable effect. The larger photograph bears the image of the old part of town in the Indian city of Varanasi. Influenced by the declining condition of the houses, this district of the city is transfigured by the soft light of the setting sun. The very dry month of March brings a layer of dust to the Indian plains. Brown tones from the dust mix with the orange colors of the setting sun, revealing other parts of the city. Such brown tones are reminiscent of medieval paintings, which are more convincing of authentic moments than saturated orange tones.

Black-and-white photography has less of a tendency to produce kitschy results. For one thing, the glaring orange of a sunset becomes a medium shade of gray. The larger photograph, from the Indian city of Puri, cannot be described as shallow. Here, old catamarans contrast with modern windmills, which decreases the risk of the scene becoming too shallow because it breaks up the modernity represented in the image.

If the small image had been in color, it might have bordered on being distasteful. As a black-and-white image, it is still bearable. The image represents a typical scene in India: a man washing himself at sunrise in a river. This ritual bears religious significance in India, symbolizing the unity of man and nature.

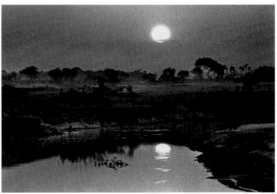

As previously discussed, images of flowers, just as with images of sunrises or sunsets, run the risk of being shallow. The top-right photograph of the hibiscus flower is a cautionary example. The image is meant to serve as a feast for the eyes, but in reality, the photograph exudes an inadequate reflection that inevitably bears a shallow effect. The small photograph on the bottom-right is not quite as bad; it no longer exhibits a typical flower shape, and is therefore more thought provoking. The larger photograph is tolerable because of its rather sharp, abstract form, and because of the color shades and textures in the background of the image. Both components ensure that the image does not fall into the category of a stereotypical image of a flower. If you absolutely wish to photograph flowers, the best technique is to incorporate the use of the abstract as much as possible in the composition. This can be accomplished by using very strong fragments of the image or by blurring large sections of the image area.

One can, of course, create beautiful images of plants without including flower petals in the composition. If you photograph branches or leaves, you need to develop an eye for concise, harmonious, and exciting forms. The small photographs above did not achieve success. The leaves are lifelessly distributed in the image area and lack composition. The small image in the upper right shows a large tuft of grass taken from an aerial perspective with silhouetted mountains in the background. It is markedly more successful than the image in the upper left, but it still lacks a truly distinctive form. The larger image accomplishes something special: the leaves of a bamboo branch resemble the brush strokes of Japanese or Chinese ink drawings. The form of the bamboo leaves on the branch is perfect in every detail. These small details bring an additional spark of tension to the composition. This photo captures the spirit of Zen—bamboo plays a very special role in Zen painting. All three pictures were taken in the Himalayas in Nepal with a telephoto lens set to a focal length of 280mm, and contain mountain ridges submerged in blur.

The Taj Mahal in Agra, India, is considered one of the most beautiful buildings in the world. It is difficult to produce a less-than-spectacular photograph of this building, even if the style is more or less conventional. The small photograph shows the familiar shot that most tourists take. This is also the image that would likely appear in travel brochures of India. It is beautiful, but it has been seen a thousand times, so appears tired and expected. The image at the top of the page is more unusual because it was photographed from an atypical location: the back of the Taj Mahal, which is rarely visited by tourists.

Here, the river can be traversed in a small rowboat that stops at a large sandbar. From this perspective, you can create an image that is very beautiful, but far less common.

Something completely different can also be created using the Taj Mahal (or any building) as an image subject. In this image, the Taj Mahal was photographed from the classic perspective using black-and-white film, but processed in the darkroom in a special way. Rather than placing the exposed photo paper in the developer, I used a brush and painted developing fluid on the exposed paper causing these sections to develop first. I then placed the paper briefly into the chemicals. This approach assured that not all sections would develop equally. The result has a completely new quality and is certainly the most artistic of the three photographs. The intent of this image was to suggest the dissolution of the visible reality. In Indian philosophy, this concept is called Māyā: illusion, deception, or delusion, behind which hides another form of existence.

That which is perceived as beautiful can be presented through the medium of photography in a variety of ways, from the shallow and cliché to the philosophical. Therefore, I recommend genuinely taking your time when you approach a beautiful object to find a meditative state of mind. This will allow you to create images that come from a source of inspiration and imagination.

# 19

# Photography as a Puzzle

Buddhist koans are verses written as a form of poetry. Their purpose is to help the mind find understanding beyond reason. "With empty hands I enter and look! The spade is in my hands." "I wander on foot and ride on the back of an ox." "I walk across the bridge, and behold that the water does not flow; rather, the bridge flows." These are some examples from John Daido Loori's, *The Zen of Creativity*. You can reflect at length on these thoughts and still not come to a logical conclusion. Koans are not the only examples in history of art that opposes the idea that logical terminology is the only way to understand reality. In some Dadaist performances, words are cut from newspaper articles and mixed in a hat. The words are placed in whatever order they are drawn from the hat to form a Dada poem. Another example is the previously mentioned surrealist paintings of René Magritte.

"As long as we view logic as final,
we are bound by it. We will not have
freedom of the mind, which will put
the truth out of sight."    Daisetz T. Suzuki

All that pertains to meditation is beyond the logic of the mind. "There is no place where you can search for the truth. Although it lies right beneath your feet, it can be found," Loori wrote in *The Zen of Creativity*. This is another statement that you could spend a long time considering. Photography too can be puzzling. It is subject to the laws of imagery, which are not necessarily logical. I have already emphasized that a contemplative approach to viewing images does not indicate translating images back into linguistic, logical terminology. Images can be emotional and ambiguous. Using imagery, it is possible to create a puzzle that demonstrates something that is considered logical at first, but seems to make no sense after really considering the aspects of the image. There is a certain charm to this; photography that uncovers ideas with hints is more exciting to observe and ponder than photography that is spelled out.

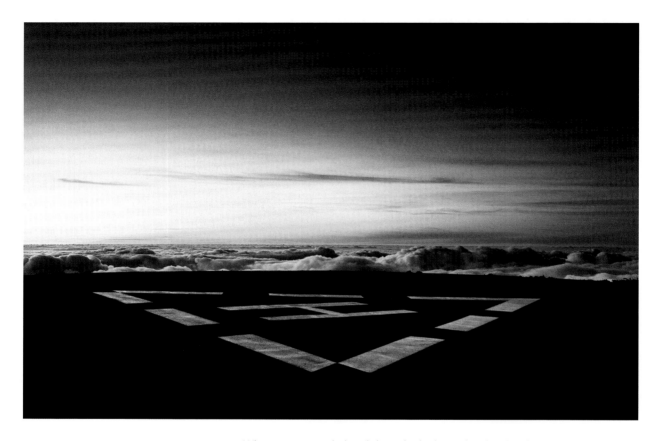

*What is an empty helipad doing high above the clouds? This image looks surreal because the elements do not seem to belong together. And yet, this place really exists. At an altitude of almost 8,000 feet, this helipad rests on a large volcanic crater, the Caldera de Taburiente, on the volcanic island of La Palma.*

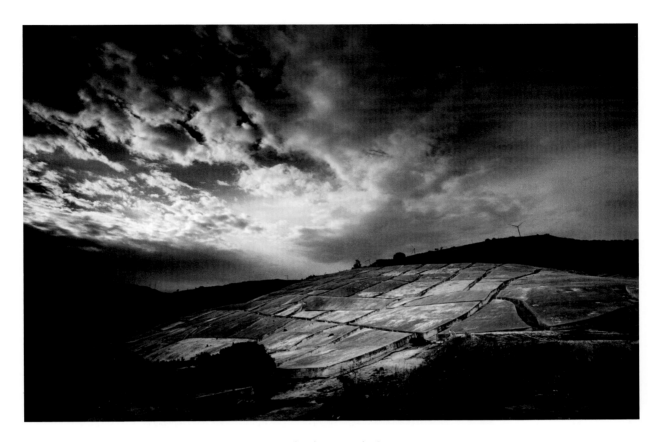

*This picture is puzzling. What kind of strange concrete landscape is this? Without a contextual explanation, this image could be comparable to a Buddhist koan in that it guides the mind to think of the things we perceive outside of the bounds of logic. Naturally, there is an explanation for the image: it is the small town and commune of Gibellina, on the island of Sicily, which completely fell victim to an earthquake in 1968. Gibellina was "rebuilt" by an artist in a special way: concrete was poured around all former streets and alleyways approximately six feet high. The concrete blocks are meant to represent former city blocks: a sort of memorial to remind us of the transitory nature of the world.*

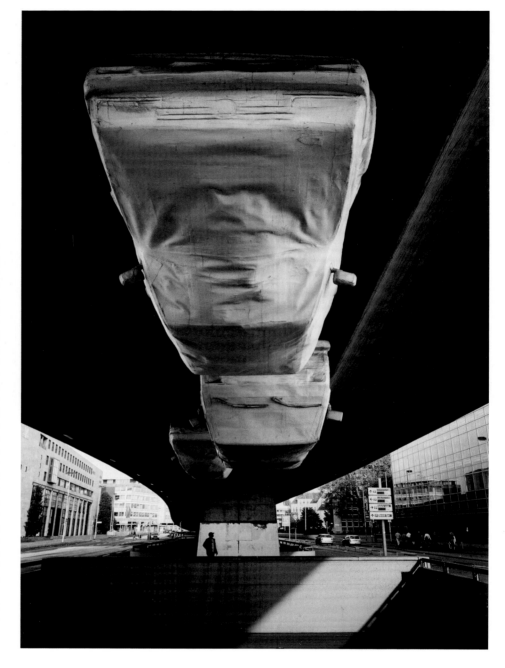

To turn things upside down is a good idea for creativity and also a good approach to meditation. Actually, images are perceived upside down by our eyes; it is our brains that invert them and allow us to see our world in the correct orientation. If we had the opportunity to practice a headstand for several days, we would eventually perceive the world right side up from the perspective of the headstand. Upon closer examination, the world as we perceive it is much more fragile than we think. The purpose of a koan is to help us break free from the shackles of the logical mind. This photograph of a work of art underneath a highway in Hannover, Germany, represents this concept of turning things upside down to perceive them in an illogical way.

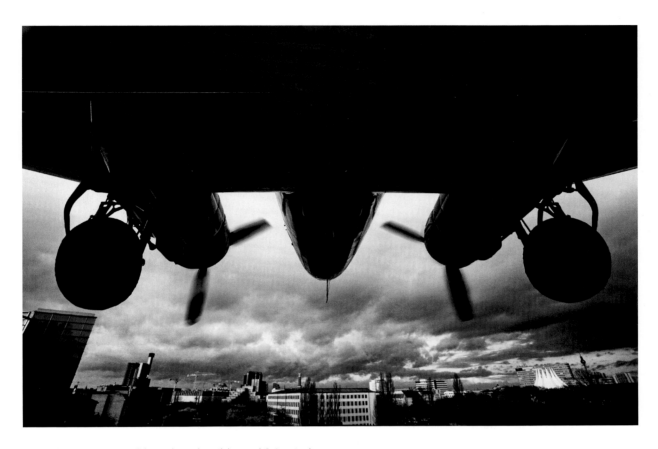

Does this scene inevitably end in a horrible crash? An airplane appears to be landing as it approaches houses without an airstrip in sight. Initially this picture appears puzzling, but not for those familiar with the Museum of Technology in Berlin, where an airplane is mounted so that you can shoot photographs from this uncanny perspective. Using the motion blur feature in Photoshop, I edited the image so the propellers appeared to be in motion, which makes the image more difficult to understand.

# 20
## Street Photography

The term "street photography" came into usage in the 1920s, but there exist examples of these types of images from as early as the end of the 19th century, when photographers began looking beyond the ivory tower of static photography, a staged and idealized art form, to pictures of "life on the streets." A type of photographer emerged who could drift through the city and its inconsistent cast of characters, capturing images using hand-held photography techniques. The underlying principles of the art form changed, allowing random, casual, surprising, volatile, and mundane urban life experiences to become the photographer's subject matter. The camera found a new role as an extension of the subjective gaze, and the metropolitan observer with a camera was born. These photographers are less interested in specific events and phenomena; they set their sights on the casualness and seemingly banal moments of the human condition in public spaces.

As the creator of his own reality, the street photographer identifies the moment that he has extracted from the stream of events. This moment becomes the subject of the image. This shows an interesting combination of street photography and the concept of meditation. This photographic form demands, more than any other genre of photography, the highest degree of concentrated attention. Street photography is common in areas with a vibrant, diverse population and a bustling, busy

energy. This means that images will be of a variety of objects that are continually in motion, and must be consolidated to create a clear composition. Successful street photographs are achieved by pressing the shutter release at the decisive moment, capturing a concise excerpt of the experience.

Henri Cartier-Bresson was a great master of taking images at decisive moments. Like almost no other photographer, Cartier-Bresson could quickly interpret complex situations as they occurred. This enabled him to know the exact second at which he should press the shutter release to capture the essence of that situation, as well as the best position to shoot from, and which lens to use. Photographers Gary Winogrand and Lee Friedlander photographed the banality of every-day life in the 1960s and 1970s. Whether the image be of a dog sitting on an empty street surrounded by unremarkable architecture, or a man wearing a hat passing in front of a McDonald's restaurant, these images could have been painted by Edward Hopper. For us, street photography should be the training field for what Zen meditation calls Samadhi, which is a relaxed state of heightened awareness. Because this important concept lends itself especially well to the genre of street photography, I've devoted many photographic examples to the subject in this chapter. Other genres, such as landscape and macro photography, are patient. This allows the photographer to let his mind wander from the immediate experience and daydream, because the object to be photographed probably will not change in those seconds of distraction. With street photography, a wandering mind can easily cause you to miss the richest moments. More than any other form of photography, street photography demands absolute presence of mind. Zen and street photography have much in common: they both require extreme mindfulness and impartiality.

Time is a requisite for successful street photography. Allowing yourself a whole day or at least half a day for shooting is essential. You will certainly not get into the desired flow or condition of Samadhi when you first bring out the camera.

Such photo sessions generally proceed laboriously. You'll photograph images that you already know will probably be mediocre. After an hour, you might see something that really touches and intrigues you. Your mind moves closer to the desired state of enthusiasm. When this state of mind is achieved, objects that trigger that photographic inspiration materializes more frequently. This is the beginning of the process of slowly, steadily coming into the state of Samadhi. Once poised and filled with enthusiasm, you press the shutter release, review the image on the display panel, recognize faults in the composition, work with deepening concentration, and shoot more images. Eventually you'll notice that hours have passed and your camera's digital card is probably full. You sense that you have captured some exceptional shots and feel the power and intensity of the process. It is natural that this intensity will not always feel the same. It rises and falls like waves. If you notice that the intensity has subsided, it is time to take a break. It is important to pay particular attention to whether you feel your process is completed for the day, or if feel you could immerse yourself again into the intensity of a new street photography session.

I have already emphasized and discussed the importance of approaching the act of photography with intuition. If you find yourself at home feeling excitement as you look at the results of your photo session, then your rational mind has also been challenged. The analysis phase of the process does not have much to do with meditation, but is still indispensable for the maturation of your photographic skills.

To illustrate all that street photography involves, these next photographs show a widely diverse assortment of city architecture, and a great conglomeration of people in motion on foot, on bicycles, in trucks, in cars, riding mopeds, or travelling by rickshaw. Organizing this throng with the camera seems almost impossible, especially if you are working with a wide-angle lens.

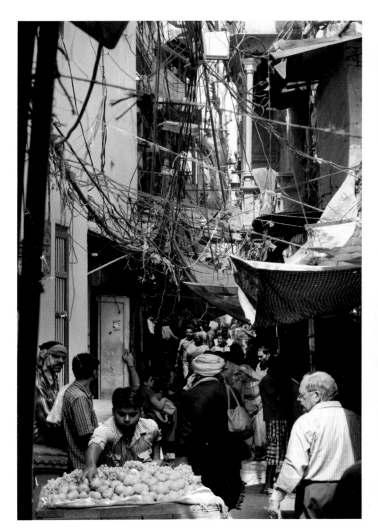

This scene is a complex arrangement of images that melds restless human affairs with a chaotic mess of overhead power cables and awning cords. This image emphasizes how critically important it is to wait for just the right moment to press the shutter button. The small image on the upper right was taken at the wrong moment: a fruit merchant, standing in the shade, turns his head away from the camera and is hidden by another person. As it is, the lower-left half of the image is unusable. But not even 30 seconds later, the scene changed for the better: the merchant rearranged his cart and leaned forward into the sunlight as he reaches for an orange with one hand. The back of a man wearing a turban is centered in the image, and a second man gazes at the merchant and his produce wagon. This image contains more successful elements, but is primarily acceptable because it is correctly proportioned and contains the important photographic composition principle of the golden ratio. (See lower-right composition sketch.) The horizontal axis of symmetry and the two vertical harmonic dividing lines are emphasized by the image elements. The arc-shape form of the wires and the awning tarps on the left and right are also somewhat axis-symmetric.

Of course, you most likely won't be consciously comparing the situation you are photographing with the analytical understanding of the golden ratio. More likely, you'll instinctively feel that the golden ratio proportion is harmonious. You'll then intuitively compose the elements with these proportions as you shoot the image, and observe the ratio later when analyzing the image.

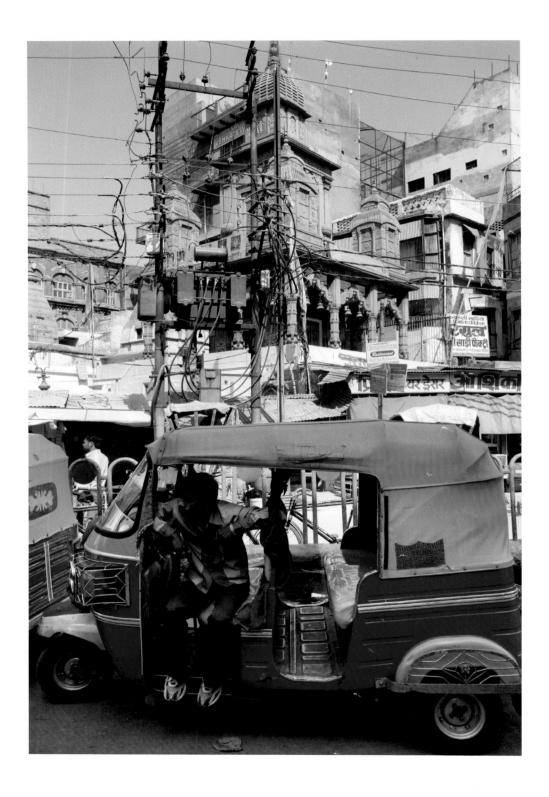

Even if you concentrate intensely on bringing movement to the focal point of an image, often the effort will result as it does in the above image. The driver of the bicycle rickshaw and his guest are correctly positioned in the composition, but the surroundings are disorderly. The driver does not stand out from the background. To the left side of his shirt, you can see an arm and a woman's head. There are people wearing white shirts who divert their gazes on either side of the driver, and the sign pole seems to emerge from his neck.

The picture on the opposite page is much more orderly. The image is limited to a rickshaw and its driver. Attention was given to capturing the right moment; there was nothing in the street in front of the rickshaw and nothing too disruptive occurring in the background. A man to the left of the rickshaw driver clearly stands out in his light shirt against the dark background. The chaos in the upper part of the image emphasizes the vertical axis of symmetry. The central axis of symmetry begins with the middle dividing bar within the rickshaw and continues upward beyond the vehicle with a power pole extending to the top of the image. The vanishing lines of a temple in the background travel exactly along the same angles to the left and right of the symmetry axis. Through subliminally perceptible image organization, the chaotic characteristics in the scene, specifically those of the disordered power lines, still achieve a balanced image that exudes clarity.

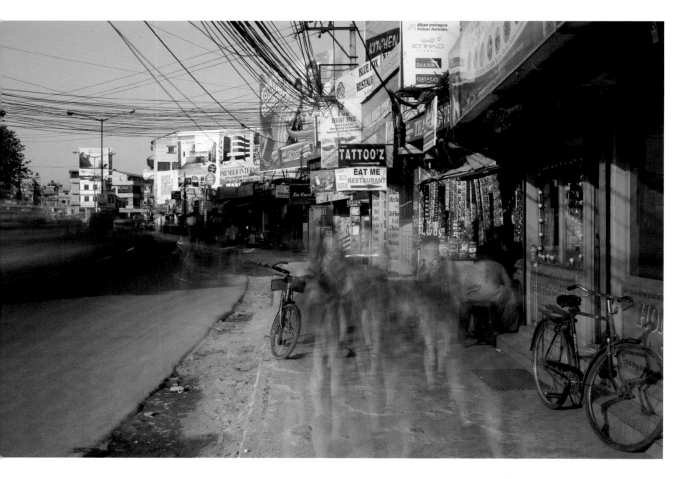

Another possibility for mastering the art of street photography amidst the confusion and chaos in a bustling city is to mount the camera on a tripod, use a neutral density filter over the lens, and work during the day using time-lapse exposures. With this method, unorganized aspects of the image can be blurred, and thus may reflect the breath of unimaginable vitality. This photograph, taken in the Nepalese capital, Kathmandu, was created using a 3-second time-lapse setting that produced a particularly interesting composition: the legs of several pedestrians join together as one structure to create a puzzle of shapes.

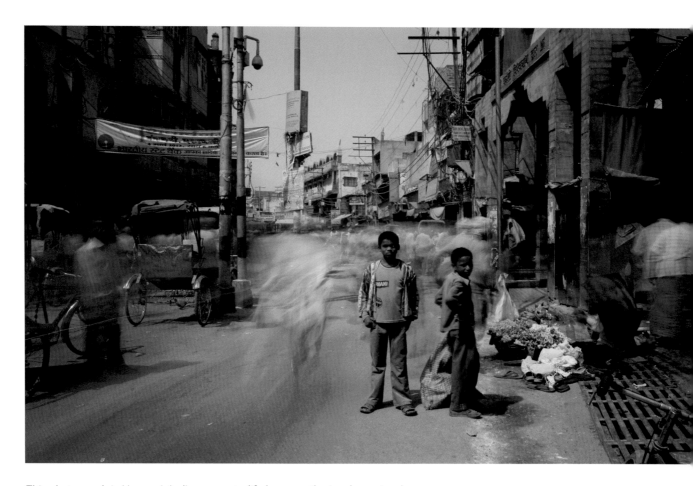

This photograph in Varanasi, India, comes to life because the two boys stand so still that their images are crisp despite the 3-second time-lapse exposure. The blurred element on their left is a cow passing through the shot. The predominant colors in the image are shades of brown, and the sky does not exhibit the typical postcard blue.

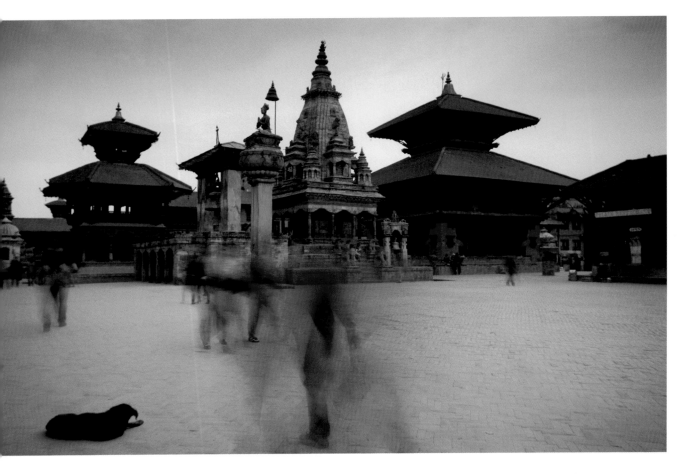

*This photograph from the city center of Bhaktapur, Nepal, escapes seeming like a postcard cliché due to the use of time-lapse photography. The fluid motion of the front figure gives an effect like an ink painting. The figure combined with the middle temple creates a central axis of symmetry. The light of the evening sky has a slightly purple hue, which is enhanced by the purple robes of the two women.*

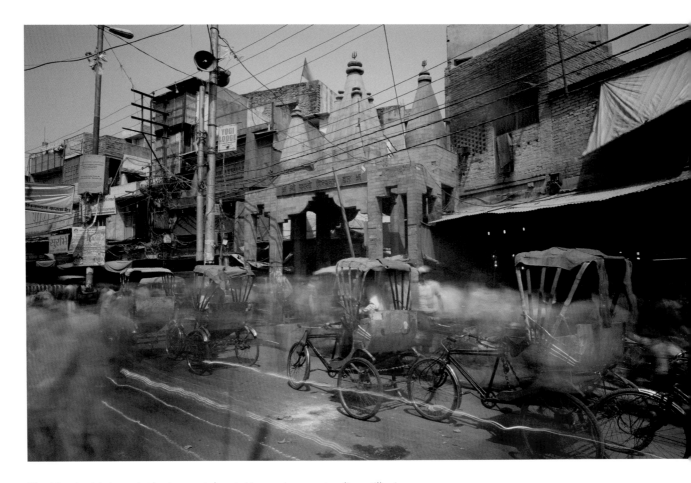

The bicycle rickshaws in the image, taken in Varanasi, were standing still, giving the photograph a calming influence. All other elements were immersed in the blurred motion of the street. The city backdrop shows the typical Indian tangle: a temple amongst old buildings, numerous cables, and billboards. Once again, brown is the dominant color.

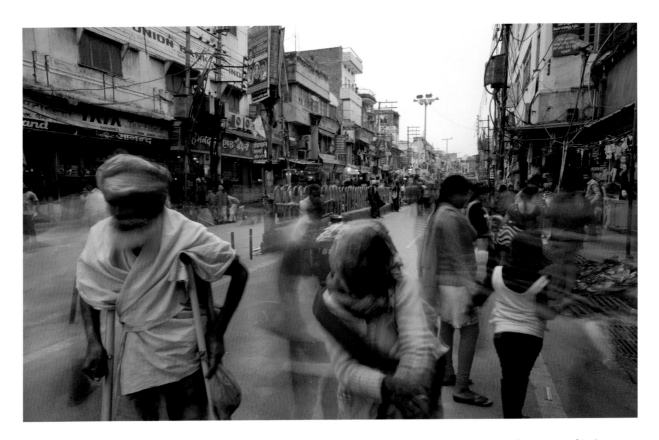

*If you are out and about as a photographer on the streets of India, especially with a tripod in hand, you will find yourself surrounded by flocks of beggars. Unfortunately, even in 2014, beggars are a regular fixture in India's streetscapes. Including them in your photographs can be a legitimate method for displaying a particular aspect of this land of extremes. It's nice to offer a few rupees in exchange, of course. Here too, a long exposure time helped to enshroud frozen poses with motion blur.*

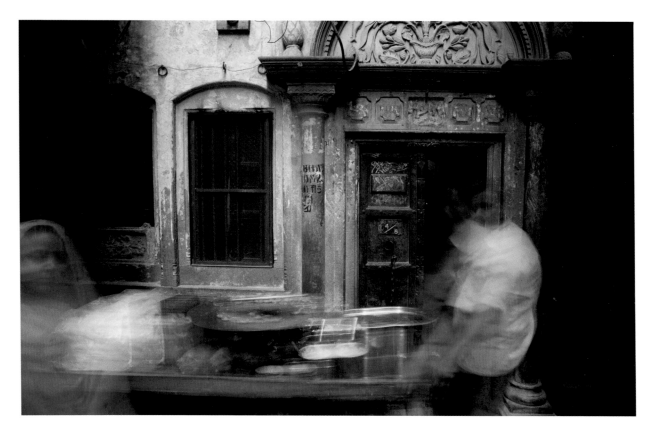

In contrast to Mumbai, the old quarter of Varanasi is attractive and con-templative—if also somewhat rundown, like almost every old town in India. This state of decay, however, often gives rise to beautiful interactions of shape and color. In this photograph, a merchant and his traveling wares produced a perfect blur of motion for the scene. The peddler stood still twice briefly during the two-second-exposure, which allowed his contours to solidify. The woman dressed in yellow further establishes a contrast of color with the blue and orange of the door.

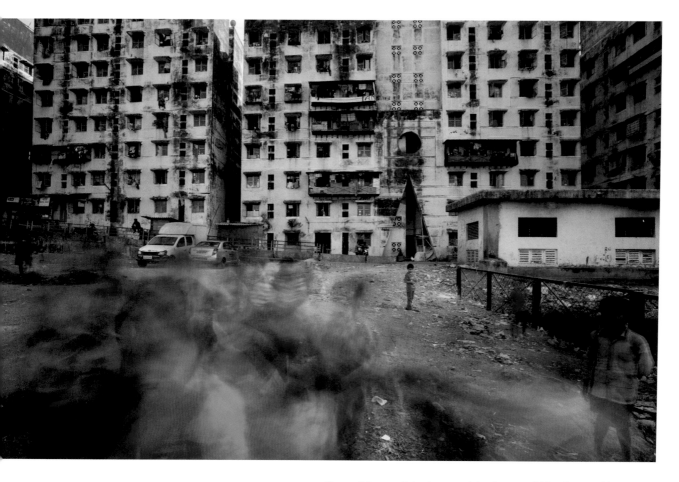

If you visit any of the impoverished areas of Mumbai, it's likely you'll quickly be surrounded by a throng of children who all want to play with your tripod and look through your camera. Directing these children for a photograph can be difficult, especially if you don't speak the language. You may need an interpreter. This photograph conveys exactly the impression that Mumbai leaves: a hurried stream of people. The high-rises in the background are social housing—after only 15 years, they are already so dilapidated that several blocks are abandoned because the danger of collapse is too great. Photos like this achieve their full effect only when displayed with an adequately large image area.

Mumbai is one of the largest cities in the world; it also features one of the world's most dramatic disparities between the haves and the have-nots. Many people live in the slums and on the streets. A photo like this is not easy to take, because the sleeper would likely not be pleased to have his picture taken. To deal with this situation, work quickly and shoot handheld with a relatively slow shutter speed (1/40 sec). In this shot, I timed my exposure with the passing of a taxi that happened to bring motion blur into the scene. Henri Cartier-Bresson once advised that a quick photo should be followed by a quick exit. I always think of his words in moments like these.

When composing image design, it is especially important in black-and-white street photography to work with graphic elements and the clearest forms possible. This interesting photograph was created in Varanasi, India. It demonstrates successful image design. Two triangle-shaped pillars of sunlight appear on a storefront, and correspond with the third element: a man wearing an Indian Kurta (traditional men's clothing), also illuminated by the sun. The florescent light on the top right is an important design element. Both the light and the man face right, while a second man exits the image travelling to the left. The two elements counterbalance each other and create excitement in the image.

The man in this photograph is embedded within very complex graphical forms. The scene was shot underneath an elevated train station in New York City. It was important to capture the man in precisely the right position. It was especially crucial to the image's success that the man's facial features stand out against the dark backdrop. To achieve such a result, you must have a high level of concentration. Prematurely press the shutter release by a few milliseconds, since even the best digital cameras have a minimal shutter lag.

An elevated railway in a Russian district of New York creates a wonderful graphic silhouette. If you discover such an interesting place, it is advisable to plan a composition and wait to capture the right person to imbed within the image. After you have set the exposure values and readied the focus, it is often wise to conceal the camera before the perfect subject approaches. This preparedness can help you avoid an occasion in which the subject changes direction or ducks if they notice your intent. In the last moment, you can quickly raise the camera to your eye and snap the image.

*This image was also taken in New York City with a telephoto lens. In this situation, you can take your time and quietly observe at length the selected section, and wait for just the right person to enter the scene. In this case, a man wearing light clothing passed by, and I took the shot at precisely the right moment.*

Berlin in the depths of winter: the dark, angular forms of the New National Gallery, designed by Ludwig Mies van der Rohe, produces a stark contrast to the snow. Two women wearing dark coats move in unison with sweeping strides as they exit the image frame. To achieve image elements that are maximally dynamic, the best moment to take the picture is, first, after the women enter the desired section of the image area, and second, as the women are mid-stride. The composition strongly incorporates the golden ratio in its orientation. A positive diagonal ascending in the image is emphasized. These components have been identified in the composition sketch.

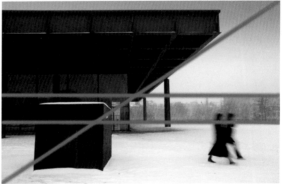

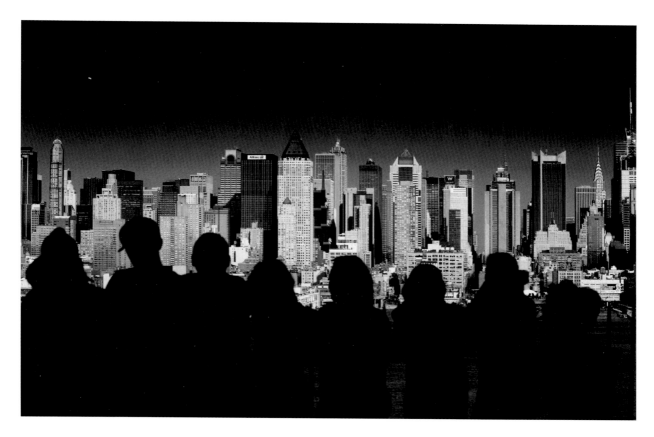

A group of young people looks across the
Hudson River toward Manhattan. Since their
bodies are silhouetted against a light back-
ground, the composition has a particularly
graphic quality. Using Photoshop, I further
edited the sky to be a darker tone, which gave
exaggerated attention the skyline of New York.

The essence of street photography is to create interesting scenes from ordinary moments in life. In this image, much remains unspoken: The person this leg belongs to is left completely up to the imagination of the viewer. This scene was photographed in the historic center of Genoa, Italy, with a telephoto lens.

Many things in this image are also left to the viewer's imagination. Three sets of legs stand against a railing on a bridge; one set of legs is flamboyantly clothed, while the other pair is more casual (the last set is of the four-legged variety). A microphone protrudes in the right corner of the photograph. This scene takes place on the Oberbaum Bridge in Berlin, Germany, during a break from a film shooting. This, too, is street photography.

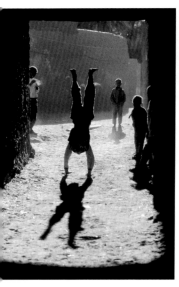

Street photography also involves bringing moving scenes into focus within an image. This street scene of a boy turning a cartwheel was taken in the Algerian city of Timimoun. The image in the larger piture was not staged; the boy in motion was unaware of my presence. The cartwheel was not a complete success, which makes the image seem more authentic. In the smaller photograph, the boy posed for the camera. The other three children are in the correct position for even composition, but the configuration was staged.

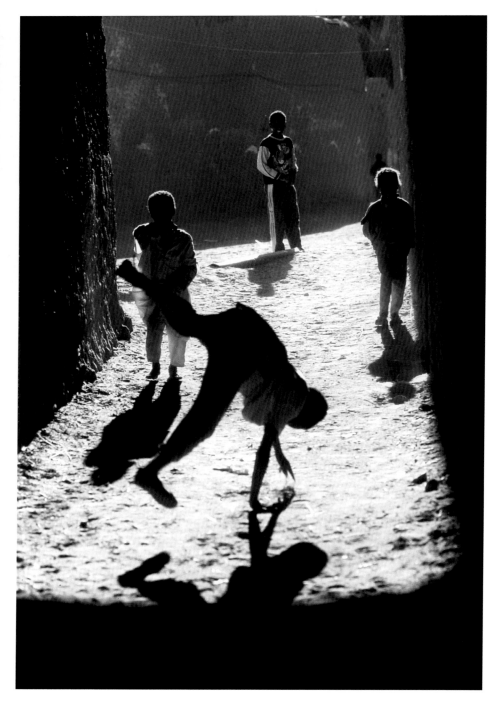

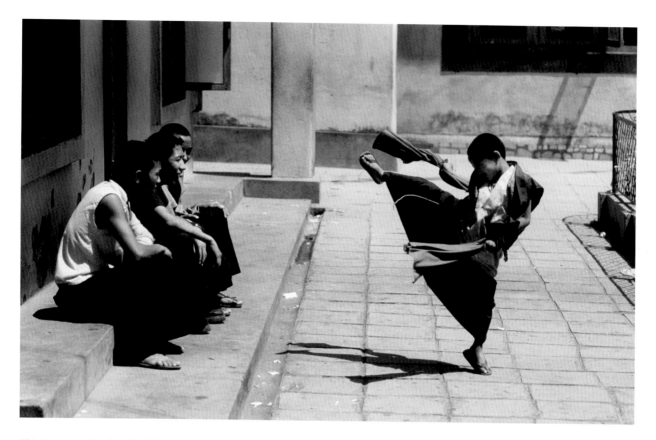

This image, taken in a Buddhist monastery in Nepal, also captures the zenith of an action
sequence. This monastery in the Kathmandu Valley also has an orphanage, where the
young monks seem quite cheerful. This photograph was taken with a Nikon analog camera.
It is more difficult to capture a precise moment using digital photography than it is working
with film because of a slight, albeit quite small, shutter lag in digital cameras.

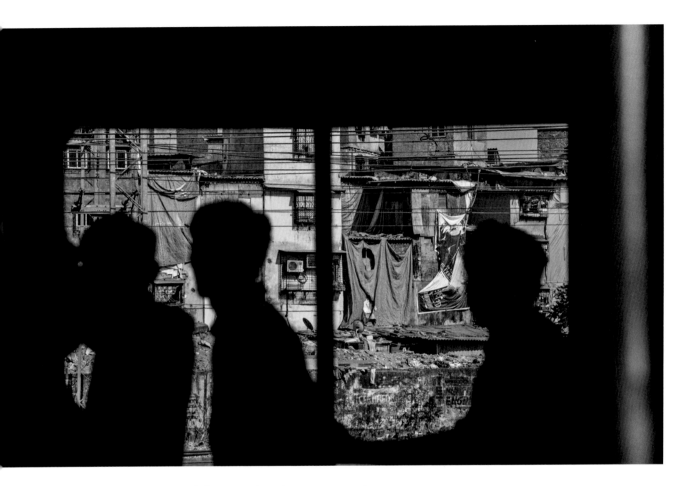

Street photography is more challenging—but also more interesting—
when you try to capture multiple layers or levels in your photographs.
Two distinct layers are present in this photograph taken in a commuter
train in Mumbai: the heads of the people in the train, and the interesting
structures formed by one of Mumbai's many slums in the background.
A heightened state of vigilance is necessary if you seek to incorporate
layers into your photographs.

The image on the next page is also composed to contain several levels. The photograph was
taken through the glass windows of a New York subway train. The first level is the reflection in
the windowpane. It fills the lower-right part of the image and displays the train platform, a view
of a house, a row of houses behind it, and the silhouette of a passing woman. The second level
shows the inside of the subway car. The third level corresponds to the view through the two
windows of the doors on the other side of the platform. In the glass pane on the left, a woman
leans against a post. In the right windowpane at the center of the image, a man with a cap
can be seen along with a partially visible companion; a row of houses rises beyond them. All
elements in this picture are interwoven, and the harmonic dividing lines are emphasized. Such
a photo is successfully created when you are in a concentrated, meditative flow.

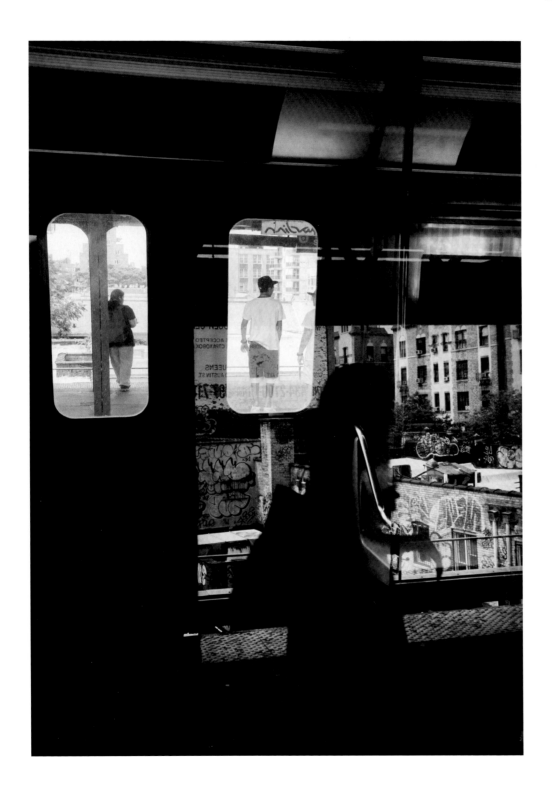

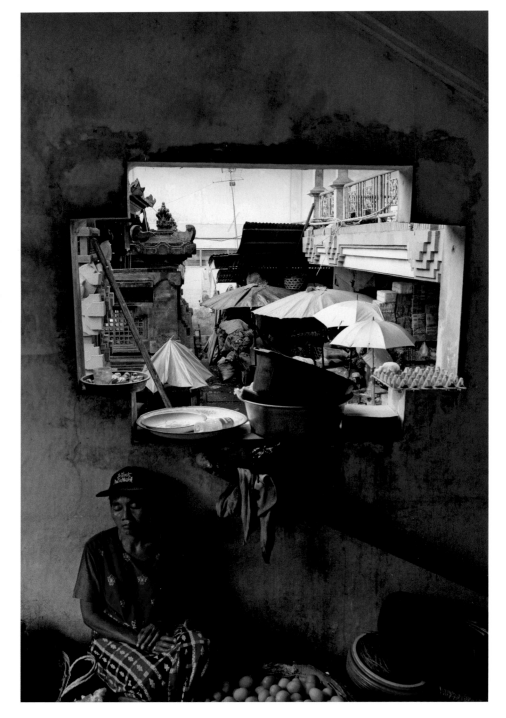

This image consists of three levels: the people sitting at the bottom of the wall, the window, and the background view beyond the window. The bustle of a Balinese market swells through the window. The entire picture, however, doesn't appear chaotic because the disorder is partially shrouded by the window. The essence of interesting photography lies in the use of different levels, which often (in the context of reality) have nothing to do with each other. When these elements appear in the image area, they meld together to form a connection. Technically speaking, such a composition presents a challenge because the greatest ratio between the brightest and darkest sections of what an image sensor can process is 1:1000.

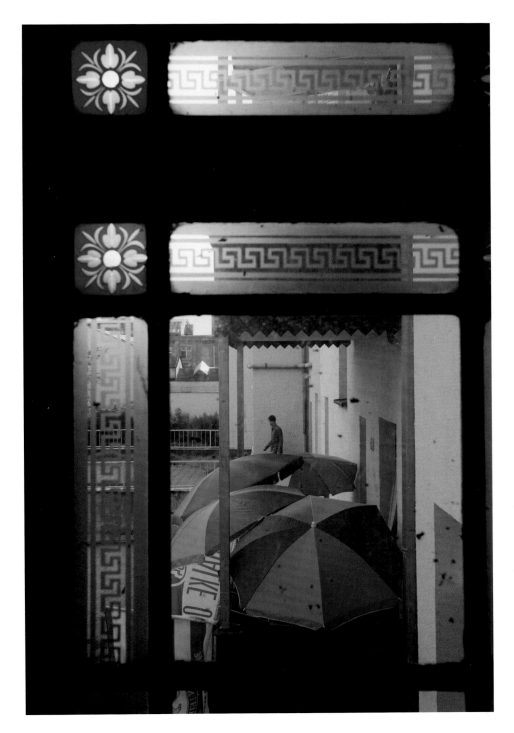

This photo is a fusion of precisely arranged levels. One level is comprised of the beautiful old windows, and the other is the view into the backyard with the umbrellas and a figure in the distance. I had to wait a while for the appearance of this person, but without the man, the photograph would be missing a key element. In other words, the figure of the man is the most important detail in the image.

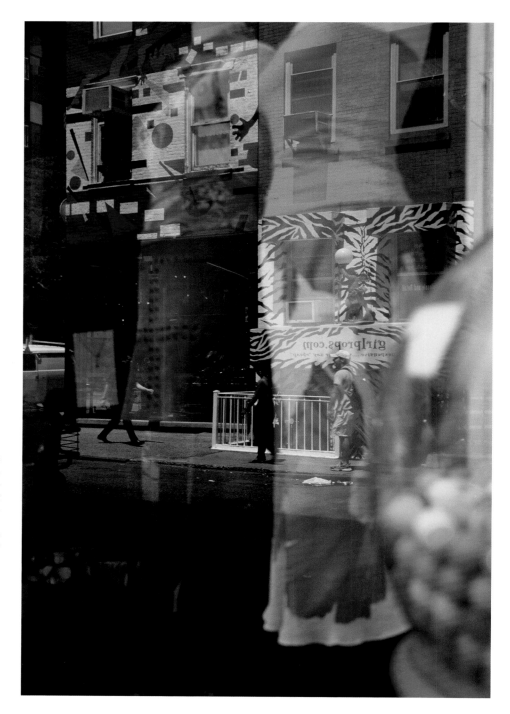

As in the previous images, this photograph also contains several levels: the front lower-right corner features the wonderful gumball machine, an anachronism in New York. The second level consists of the two mannequins inside the store. The third level, which is mirrored in the window, is the main level of the image, which shows a street scene with three people. The dominating colors in the image are on the red-orange spectrum.

Images like this one portray a sort of poetry. What is occurring behind the rainy windowpane is immersed in a blur—there is only a hint at the fact that this is one of the most vibrant neighborhoods in New York City's SoHo district.

# 21
# Creating Special Magic

I believe that street photography has much in common with a meditative approach to photography—because street photography can include a variety of photographic styles, it requires a heightened level of attention. The resulting images of life in metropolitan cities, however, are not what most people would commonly associate with images that inspire a meditative calm. Usually people consider images that exhibit stillness or convey a special mystical quality to be more indicative of a meditative mood.

The basic building block of photography is light. All moods in photographs are influenced by light. Photographing the same subject with different lighting will produce completely different results. Lighting reveals aspects of the scene or subject, so lighting something in a variety of ways will create a variety of images, each that tell a unique story. Early photographers were referred to as creators of light—image designers who had the understanding and skills to work with the mystery of light.

Physically, visible light is a mixture of electromagnetic waves with a bandwidth of approximately 400 to 700 nanometers (between infrared and ultraviolet light). The eyes and brain translate these vibrations into the different colors that we perceive. As a photographer, it is important to use these colors to create interesting images. Especially when considering color photography, it is particularly important to comprehend that

The basic building block of the photograph is light. That is why early photographers were referred to as "creators of light."

light is influenced greatly by the time of day, weather conditions, and also the season. For example, warm orange hues are most prevalent during sunrise and sunset, and cooler, blue components of light are most prevalent before sunrise and after sunset; hence the familiar term "the blue hour."

The most neutral light occurs in gray weather because the color properties of a given object are most authentically reproduced. It is not a coincidence that Bernd and Hilla Becker, who wanted to objectify the subjects of their photography, worked mostly with this type of light. In contrast, midday light with a blue sky often produces an effect in which the objects in a photograph look pale. Of course, the color temperature of an image can be corrected by using image-editing software, but this sometimes produces an unnatural effect. It is advisable to be patient and be on the lookout for unique lighting situations. Practicing patience and learning how to do nothing when there is nothing to do is also a type of meditation. This especially applies to the art of photography. A photographer's most difficult discipline is to refrain from pressing the shutter release button when there is nothing special in the scene before them. To create magical photographs, you must wait patiently until a moment arises that moves you intensely. Meditative photography embraces the enthusiasm that occurs when photographers witness subjects, moments, or scenes that inspire them. This enthusiasm creates the perception of unity between the camera operator and subject.

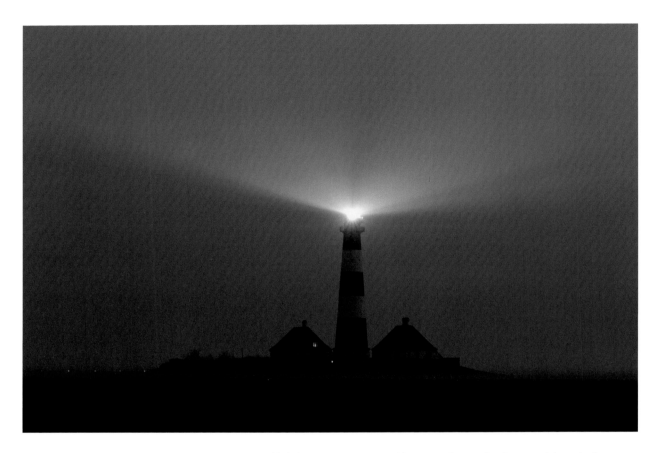

Lighthouses are treasured because they embody a special symbolic power. Not only can a specific lighthouse represent a certain region, as does the image of the famed Westerhever Lighthouse in Northern Germany, lighthouses also symbolize a safe haven or a light in the darkness. With the art of photography, it is possible to visually express the emblematic power of a lighthouse. This can be achieved by embedding a lighthouse in an image shrouded in darkness; in this image, I used the mist of dawn as the background, which gives the image a mystical quality. The color purple communicates melancholy and depth in photographs. Understandably, such an image appears a little cliché, but it also has a sense of magic.

*Kathmandu, the capital of Nepal, is an example of an Asian metropolis in which pagoda temples are predominantly the tallest buildings in the city. In this image, the city is blanketed by a very unique cloud cover that lends a sense of magic to the photograph. Generally, photographs of red skies can border on seeming cliché, especially if there is a setting sun involved. The sky in this scene, however, contains two dark clouds that add heaviness to the image. Durbar Square in Nepal's capital looms silhouetted against a red sky. The sharp edges of angular roofs with chimneys and antennas stand out against the colorful backdrop, as do the two pagoda temples and a palace on the photograph's right edge.*

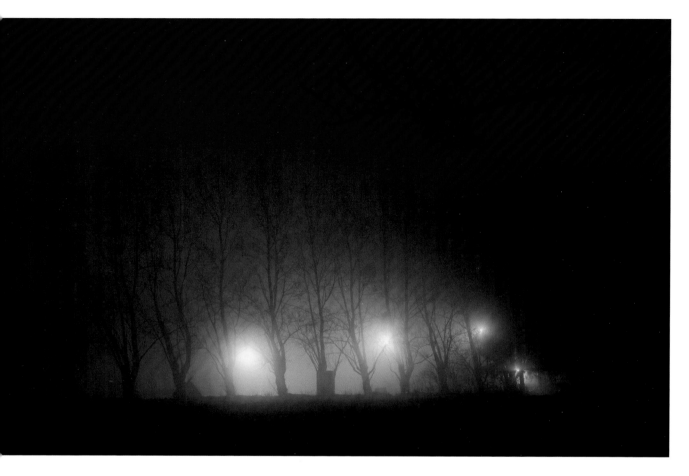

*Capturing the magic of the night gives you the opportunity to bring mystery into a photograph. Winter, more specifically November, with its fog-cloaked moods, is an especially good time of year to achieve this. These types of situations can come as a complete surprise. I came upon this scene on a section of roadway I travel almost daily near Goslar in the Harz Mountains of Germany. Floodlights illuminated a sports field during an evening soccer match behind a group of bare trees nestled in fog mist. Never before had this particular row of trees appeared so enchanted. It didn't take much time to set up the tripod and capture the image; not long thereafter, the fog disappeared and the floodlights were extinguished.*

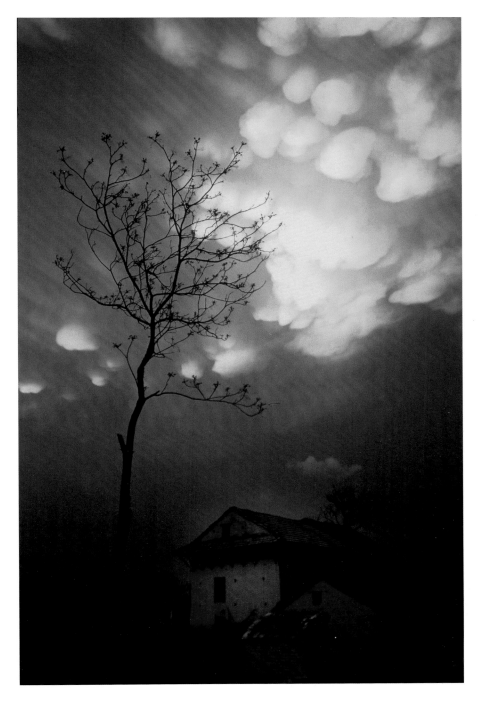

Remarkable moods pro-
duced by sky illumination are
generally short-lived, so you
should work with expedi-
ency if an unusual formation
presents itself. The image
depicted here, taken in the
Kathmandu Valley of Nepal,
is an example. In such a situa-
tion, it is advisable to capture
an image quickly, holding
the camera even if the light
meter indicates a shutter
speed of 1/15 second with a
wide-open aperture. Success
can be accomplished with a
20mm wide-angle lens and
a steady hand. Thereafter,
set up your tripod. With a
little bit of luck, the right
mood will still prevail when
the camera is mounted and
ready to shoot the photo-
graph. When mounted on the
tripod, a smaller aperture can
be set. Pressing the shut-
ter release without shaking
the camera is easier. These
details will enable you to
achieve optimum focus. The
combination of clouds, an
impending thunderstorm,
and the light of the setting
sun is extraordinary. It gives
the photograph a dramatic,
almost mystical quality. The
coloration imitates a painting
by Rembrandt, an artist who
used light and shadow to
accentuate and illuminate
details.

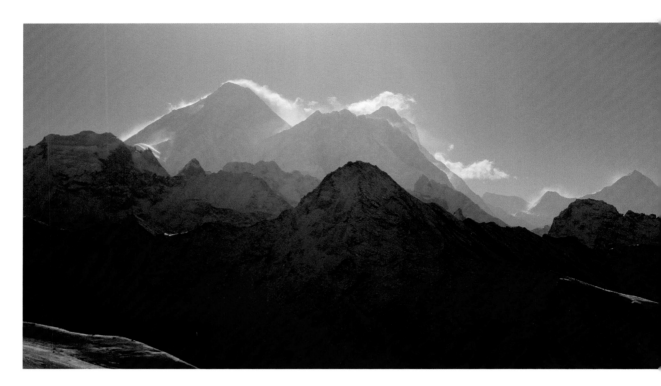

The top image was taken at an altitude of almost 18,000 feet from the Gokyo Peak in the Nepalese Himalayas. The blazing bright clouds behind Mount Everest, Lhotse, and Makalu were illuminated by the morning sun, which rose over the mountains shortly after this photograph was taken. These meditative moments are the ones that you as a photographer will never forget. The bottom picture shows an early morning in Phewa Lake in Nepal. For me, the boat symbolizes the mind, which can, through meditation, cross into a still and mysterious spiritual world. This moment also held incredible magic.

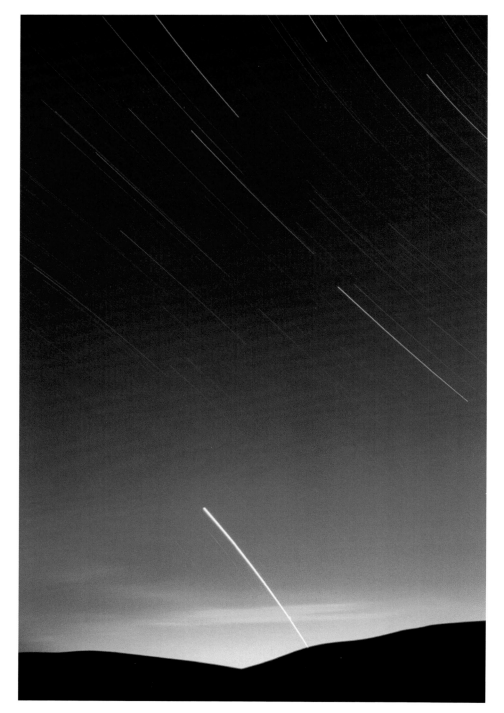

This picture was taken in the Algerian Sahara. Using a lockable cable release, the exposure was taken over three hours, a time period that began at semi-darkness and continued deep into the night. The cosmos with its millions and millions of stars is visible, and their paths can be mapped using photography. This image shows that almost all stars have a different color, and that photographs of the sky can reference the metaphysical in a special way. Use of film and an analog camera is still the best way to capture an image that requires an exposure of several hours. The camera used for this image was a Fuji Provia. The image was later scanned and edited.

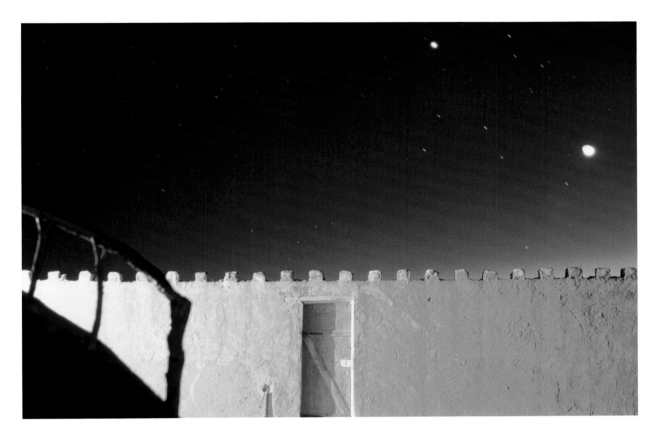

This photograph was exposed for approximately one minute, but even at this brief length of time, movement of the stars is visible. The wall, which bears interesting characteristics, encloses a small oasis near the Algerian town of Timimoun in the Sahara. The contrast of the almost orange wall and the complementary blue of the night sky creates harmony.

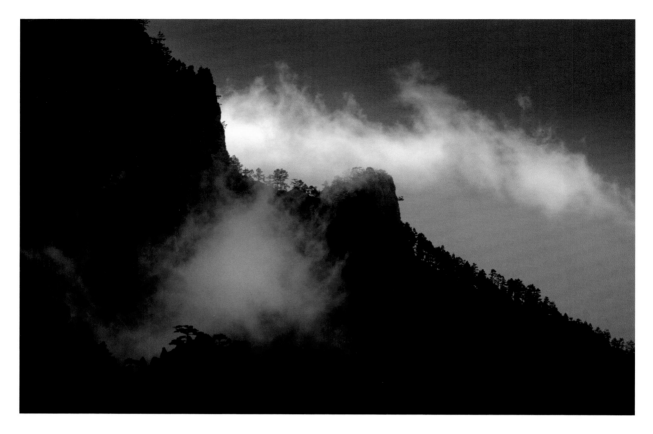

The special magic of this image is attributed to the uncommon blue tones of the clouds. The color rises from the shadow of Pico Bejenado on La Palma in the Canary Islands. The cloud behind the mountain remains illuminated by the sun. The contrast between these two clouds creates the magic in the photograph.

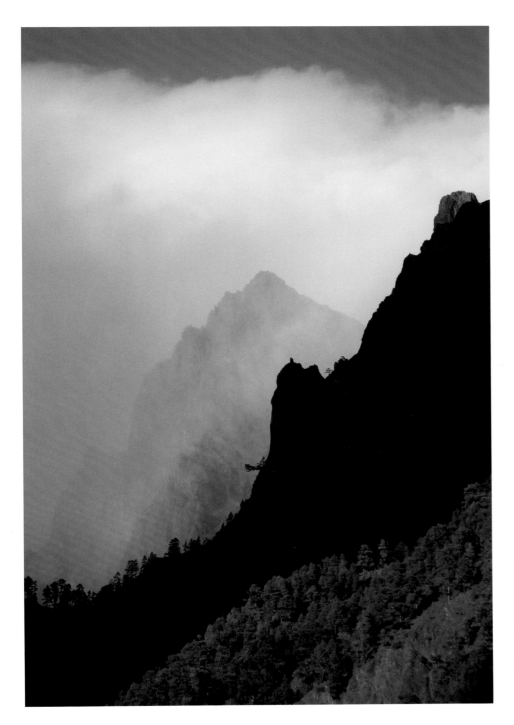

The play of light and shadow creates the necessary energy in this photograph. Naturally, the outstanding feature of this image is the rainbow located behind the shady part of the cliff. Shadows and the rainbow define the positive diagonal of the image.

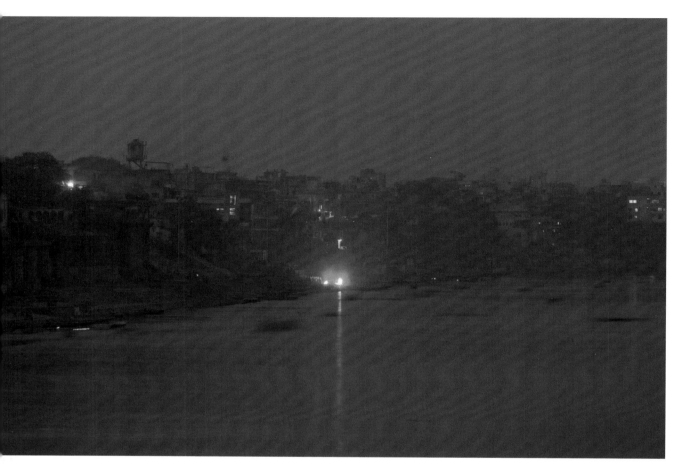

One of the most magical places in the world is Varanasi, India. Faithful followers of Hinduism continue to make the pilgrimage to the Ganges River to meditate and perform sacred ablutions. Oak funeral pyres burn day and night because dying near the Ganges helps achieve a better rebirth into the next life. It is by no means necessary to photograph funeral pyres at close range to capture a mystical image. Even at great distances, the fires dominate the cityscape on the Ganges—especially against the dim background of the riverbank at night.

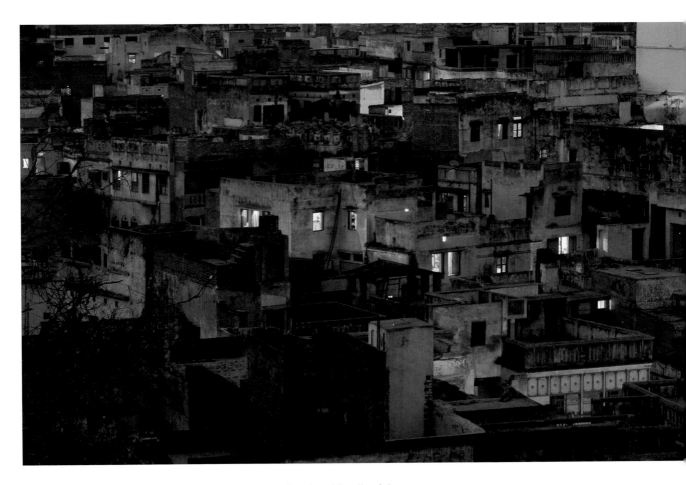

*If you gaze over the rooftops of Varanasi, you realize that the old walls of the city have hardly changed in centuries. In this city, modern life exists next to ancient relics, which is precisely what gives it special magic.*

# 22

# Photography as Ink Paintings

Ink painting is widely regarded as an artistic expression of Zen meditation. In Japan it is called Sumi-e. It combines simplicity with forceful expression and allows the blank sections of the paper to speak. The use of only black ink on white canvas creates rich nuance. This type of painting is full of paradoxes, but nothing less could be expected from Zen. The principle of "non-expression" is typical in Zen. With ink painting, non-expression refers to the idea that you should not attempt to express yourself in the first instant, but rather work with ease from a place of spiritual void. The most powerful ink paintings are the ones in which the negative space on the paper speaks as much as the trail of black ink left by the paintbrush. Meditating before beginning the painting process is customary.

Using meditative photography, you can try to produce images that are patterned after the art of Japanese ink wash painting. It is especially true with this type of art that achieving a meditative state of perception allows you to be sensitive to the subtle interaction of light and dark, as well as the importance of the spaces of emptiness on the paper.

The concept of letting emptiness speak is illustrated in this image. Snow-covered branches barely cover half of this photograph, yet their power reaches far to the left, filling almost the entire white, snow-covered surface with a hint of life.

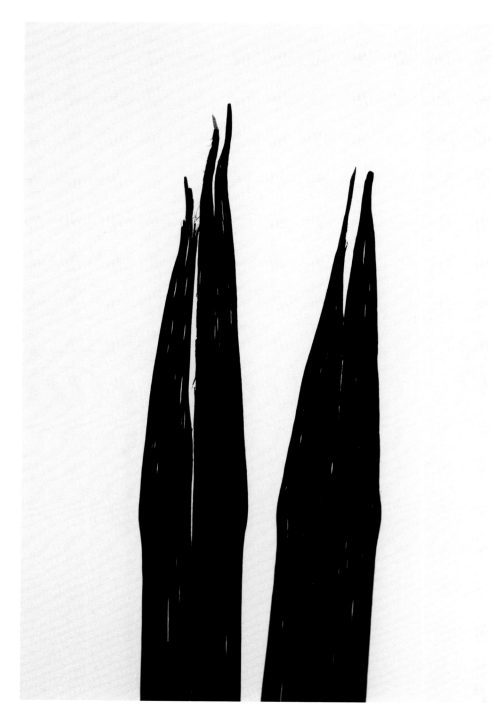

Empty space, once again, dominates the image area of this photograph. The tips of two palm leaves bear resemblance to the brush strokes of an ink wash painting. In Chinese calligraphy, the form of a character relates to the soul of the object it represents. Chinese calligraphy and Japanese Zen ink paintings share common roots, just as the origin of Zen philosophy stems from China.

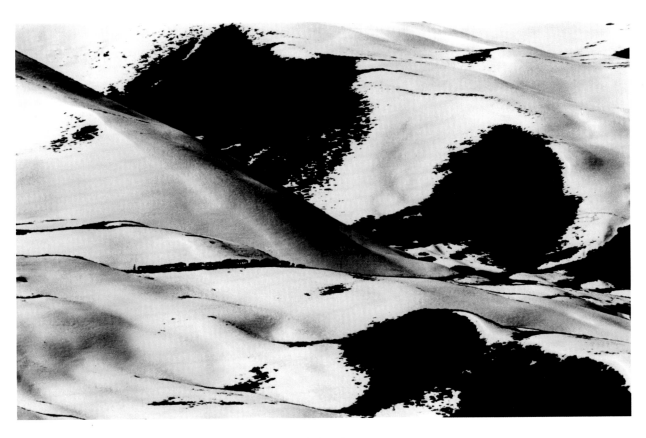

*In this scene from the Himalayas of Nepal, the image area below the Dhaulagiri massif portrays a much more balanced distribution of light and dark areas. The snow image on page 197 appears delicate, whereas this photograph evokes more power. It shows the interplay of snow-covered surfaces and areas of dark earth. A small, migrating caravan of yak can be seen in the distance.*

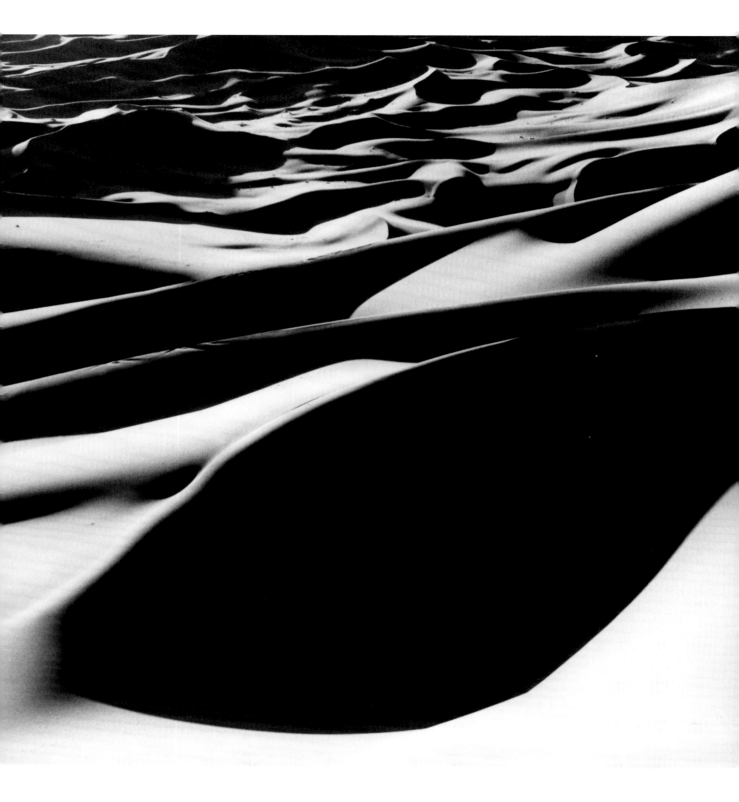

This photograph was taken in the Algerian Sahara desert. The anterior dark area of the image dominates and creates a dramatic effect. The Sahara is one of the emptiest landscapes on the planet, and therefore an ideal spot to broaden the mind and photographically mimic the characteristics of ink paintings.

This photo of a banana plant leaf also bears resemblance to an ink painting;
even if no empty, white areas are present in the image. It contains mixed
gray tones and soft, almost black shadow lines that cross the leaf diago-
nally. These shadows are framed by a small black area on the left side of the
image and a large black area on the right side of the image. The interaction
of shapes creates excitement in the image.

*This photograph is reminiscent of an upward brush stroke in an ink drawing. There are many examples of similar curved forms occurring in nature; to discover their beauty, one needs patience and an open mind.*

# 23

# Magic in the Detail

Slowly walking through nature can be a contemplative act; once you're in an introspective mood, keep a watchful eye for details in your surroundings. Macrophotography provides an interesting way to focus on tiny details of objects and bring them into focus as the subject of your images. From this macrophotography perspective, nature can be revealed in a special way.

I would like to discuss some of the technical obstacles that macrophotography presents. At close range, the depth of field is extremely shallow. A deeper depth of field is necessary for most subjects to prevent a large section of the image from being out of focus. If you want to achieve a deeper depth of field in the macro range, you must set the aperture to 16, 22, or smaller, if possible. These aperture settings produce longer shutter speeds and make it necessary to use a tripod. Surely the smallest hint of wind will ensure that the object of the macro image, such as a tender plant, will blur at even a 1/15-second exposure time. What is the solution? Increase the ISO speed immeasurably? Under these conditions, the image quality suffers even with the best and most modern digital cameras. The bottom line is that good macrophotography requires a compromise of all factors: a relatively high ISO number, but not exceeding ISO 1600; a relatively closed aperture; and a minimum shutter speed of 1/30 second, unless the conditions are completely void of wind.

"To see things in the seed,
that is genius."                    Laozi (Lao Tzu)

A good course of action is to use a macro lens with an image stabilizer, which will allow you to capture the image free-hand with longer exposure times. This is important because it is not always possible to set up a tripod every time you wish to capture a scene. Extremely high-resolution cameras, such as the Nikon D800 or D810 and the Sony A7R (which all have 36-megapixel sensors), or medium format digital cameras, have a higher tendency to blur objects than lower resolution cameras. This happens primarily because the higher resolution amplifies the amount of blur present due to any camera motion. When working with such cameras, the shutter speed must be very short (1/100 second or shorter, for example) depending on the chosen focal length—even when using an image stabilizer. With cameras that have a 10–20 megapixel resolution, you can work with speeds longer than 1/100 second, especially if you are using an image stabilizer. This means spending more time with technology than with the subject of your images, which means that it is more difficult to create photographs in a meditative state of mind. Meditative photography is not about being technically proficient, but knowing your way around your camera will help free your mind of the concentration needed to choose applicable camera settings in any given situation.

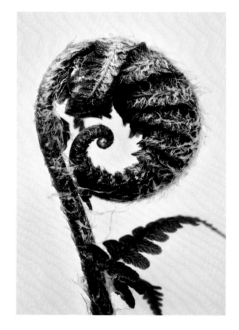

*These four images pay hom-
age to the work of German
photographer, Karl Blossfeldt.
These photographs depict
a variety of forms in early
spring, before nature unfolds
itself in the form of young
plants and animals. The fern
and the snail are examples of
the spiral, a form that is very
common in nature. The spiral
is the iconic representation of
development and growth.*

In this image, spiral threads branch off of this palm leaf. Here, the aperture was set at 10. It was a compromise to capture just enough sharpness to allow clarity for the spiral, but to also keep the background immersed in enough of a blur that the thread clearly stands out against it.

In my photo-graphic series called "Architecture Follows Nature," I describe the details of forms in nature and how they often assume an architectural feel. In this body of work, I pair images of shapes in nature with their archi-tectural counterparts. In the images on pages 208 and 209, you can see the comparison between a dandelion and the cool-ing tower of a coal plant in Heilbronn, Germany.

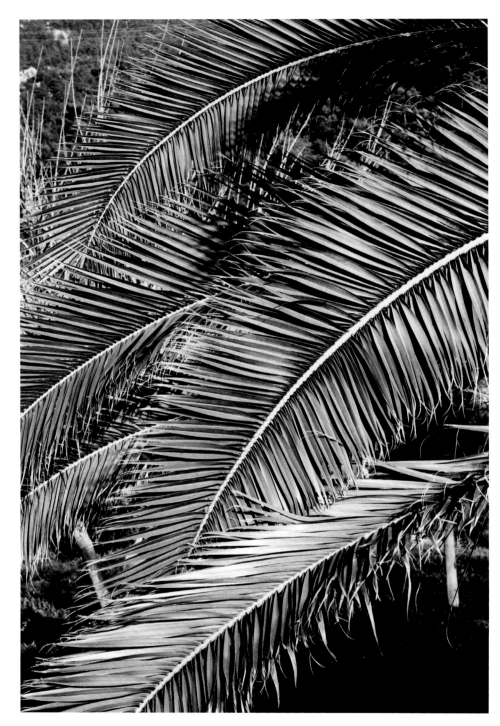

In an earlier chapter, I mentioned that the Chrysler Building in New York City bears likeness to a palm leaf. Many attempts were necessary to successfully illustrate the resemblance between palm leaves in nature and the architectural leaves of the building.

# 24

# Abstractions

The naturalistic painting style of the 18th and 19th centuries in the West has been all but replaced by photography. Beginning with Impressionism, painting has gone in a different direction, distancing itself further and further from a naturalistic point of view.

Photography has assumed the task of representing the world in a realistic way, but it has also freed itself from this limiting view of reality. For example, the work of photographers such as Alexander Rodchenko of Russia and Laszlo Moholy-Nagy of Hungary makes a point to extract photography from the convention of a naturalistic representation of reality. To date, many forms of abstraction have been used in photography. The abstract is disengaged from the concrete and the literal. Abstract thoughts break away from the actual object and develop a life of their own as a representation of the concept of the object. The same idea can be applied to images. A painting is an abstraction (or a re-creation of shapes and colors) even when based on reality, but a photograph actually captures the image of an objective reality. However, photography can be abstract if the abstract structure of an image becomes the content of the image. All image content is based on an underlying abstract structure. Most viewers are accustomed to paying attention primarily to the more recognizable image content, but the image content becomes more powerful and

Abstract photographs start like abstract thoughts: they detach themselves from the subject matter and develop a life of their own.

interesting to look at when the underlying image structure is regarded and considered, as well.

Now we will return to meditation and creativity. A regular meditation practice fosters the conditions that enable creativity. Creative design in photography may also be achieved if the photograph is turned upside down and viewed abstractly. By doing this, the references to reality that exist in the image are relaxed and the abstract fundamental structure becomes apparent. This is also considered a re-creation. To accomplish this, you must develop an eye for the non-representational shapes that underlie objects. Then using the viewfinder, frame these objects and work to create an exciting, abstract image structure in reference to form and color. This structure is the pattern of the underlying image, the play of lines, shapes, structures of all types and colors.

When you make a point to really study the photographs you take (or the photographs of others) you'll begin to notice the balance of form and content. Either form or content can be dominant in an image, but some images have both aspects in perfect equality. The images in the following pages show how the abstract form can be superimposed on the content.

*White masonry walls on the island of Lanzarote in the Canary Islands are photographed from below, looking upward toward the blue sky. This image is far from a typical postcard cliché and conveys a pure language of form. The image reveals an abstract life of its own among white and light blue-gray rectangles against the blue sky. At first glance, it is difficult to discern positive from negative form. The image could almost give the impression that the sky is in front of the white areas of the walls. During meditation, seemingly secure objectivity can begin to dissolve.*

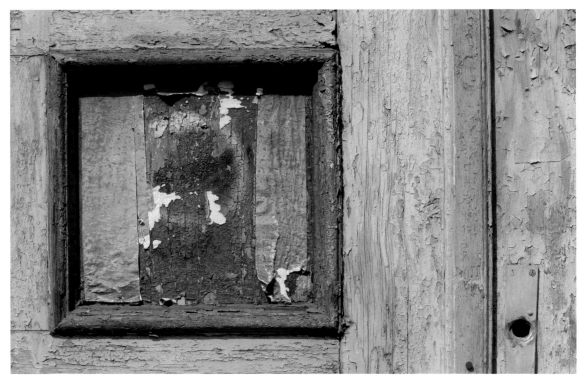

*In Germany, a door of this kind quickly falls prey to restoration efforts. The structure, which shows years of slow damage that has eaten away at the door, is a form of abstract art. German painter Kurt Schwitters, the master of abstract décollage, could hardly have painted a better picture. In this image, the aim is not to give up the entire relationship to objectivity. The image incorporates a strong golden ratio. The right line of the square is exactly on the right vertical harmonic dividing line. The clear structure contrasts the many organic forms.*

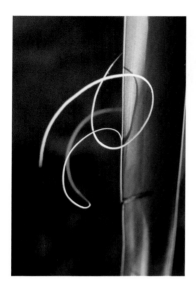
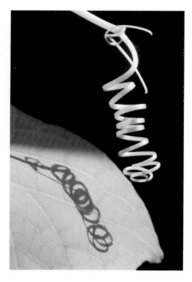

In previous chapters, we discussed how the macro range also offers numerous possibilities for image design. In the upper-left image, two small sweeping fibers are contrasted against a palm leaf. The left edge of the leaf runs harmoniously along the left vertical dividing line. The small image on the right shows the momentum of a coiled form with its shadow cast on a leaf. This image illustrates abstraction through the presentation of its details.

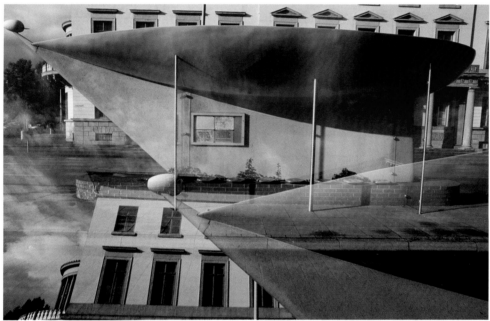

The larger image is a carefully planned double exposure. The artistically designed bus stops in Hanover, Germany, are easily recognizable and fill half of the image content. A fairly benign gray street occupies the lower section in the first image, which needed to be filled in the second exposure. The result exposes a partial view of the boat-shaped bus stop and the left side of a classical villa inside the lower image area. The sky in the second shot settles over the main section of the first image creating an interesting, slightly cubist composition. Cubist painters also deconstruct their subjects. The aim of analytical cubism is to combine multiple perspectives of an object within the image.

This photograph was taken in Offenbach, Germany, in an old factory that provides studio space to artists. Shape and color are blended with the content of the image. The red plastic curtain that hangs between the two rooms is particularly striking, and dominates the angular composition of the image.

The subject of this abstract image design is a twisted strip of plastic that has separated from the edge of a New York City subway platform. On the back wall beyond the tracks of the station there is an indentation that forms a rectangle. The spiral tip is framed by this rectangle in a kind of image within the image.

*The art of meditative photography is the art of observing the world with contemplation. This photograph is of the view through an artistically designed glass window in Bremerhaven, Germany. Sailboats immersed in blue light take on similar characteristics of a cubist abstraction.*

Cloths hanging in front of windows in a hut in Bali give the appearance of prayer flags. The cloths work together with a picturesque background submerged in blur. Photographic abstraction means creating a rhythm and pattern of color tones that harmonize together. The lower photograph is brought to life by a series of lines on a sheet of plastic placed in front of a window. Once again, the image involves only form and color that is detached from the object as it appears in the context of reality.

# 25

# What is Creativity?

This question about the nature of creativity is not easy to answer. Creativity is difficult to define and even more difficult to substantiate with empirical scientific methods. In the classical sense of the word, creativity is associated with thoughts and actions. In modern art and photography, creativity is aligned closely with originality. Whether it be ink paintings or the art of photography, creativity in reference to Zen meditation is certainly also an act of creation, but it does not originate in the mind. It stems, rather, from the whole being of the person. Creativity within the context of Zen is not forced or compelled to create something original. Artistic originality, whether in paintings, ink drawings, sculptures, gardens, or even photographs, reveals itself far more subtly.

Despite the fact that ink renderings often depict bamboo or landscapes, each of these art pieces is original because each painting is inspired by a creative mind at a particular time and place. Photographs that are a product of inspiration rather than shallow kitsch also carry this quality of having been created from a deeper source than a casual snapshot. Consider, for example, the photography of Ansel Adams. His work has become world famous, yet in the history of photography, his images have not introduced a truly new way of seeing nature. They are very classically composed and in some ways, not innovative.

Nevertheless, the work of Ansel Adams has rightfully earned him worldwide fame because his images are penetrated with incredible depth. The images often hold a

"My creative process is similar to pregnancy in that I am giving birth to a new being."
                                        Paulo Coelho

mysterious force—a spell that cannot be explained by Ansel Adams' Zone System and large-format cameras. Adams' photographs bear witness to the oneness of the photographer with nature. That is exactly the kind of creativity to which Zen refers. Consider the work of photographer Bruce Davidson, specifically his series "East 100th Street." Davidson's photographs of a single street in Harlem are the product of a two-year intensive debate between the street and its inhabitants. These images have an intensity that no voyeur could hurriedly achieve on the fly. They are not "innovative," but they bear witness to how, at certain times, the photographer and his work become one with the surroundings. That is exactly the kind of creativity to which Zen refers. This kind of creativity is not forced or arduous; it surfaces from deep within and is not only a product of the intellectual, conscious mind. How can you foster this type of creativity? It does not lie at your fingertips; you can only create conditions that encourage such creativity. These conditions are certainly different for everyone. There are people who are most creative when under pressure, but not everyone can work like that. A regular meditation practice is a good foundation that can allow for creativity, but it does not come with any guarantees. For most people, myself included, creativity has a lot to do with relaxation and the feeling of having ample time. Creative ideas come from within. They surface in the mind, usually without any effort, during a heightened state of relaxation.

I came up with the idea for my series "Janus Views" during such a relaxed frame of mind. At the seashore in Barcelona, I asked myself why people oriented their chairs toward the sea and not in the opposite direction. This idea seemed so absurd to me that I imagined photographing the opposite perspective of a beautiful seascape and presenting it to the observer. It was at this moment that I was struck by the idea to photograph the same image from the front and rear views. Creativity does not mean that a single idea will necessarily evolve into an entire project. Creativity reveals itself every time you are profoundly touched by some external reality that compels you to capture expressive photographs. I have mentioned several times that this form of creativity occurs without effort. It is not inhibited or filled with intent; rather, it is a flow that you enter where you allow emotions and ideas to happen organically. This kind of creativity generally produces photographs that have originality; proof of a genuine enthusiasm about a specific moment and a particular location that is carried over into the image.

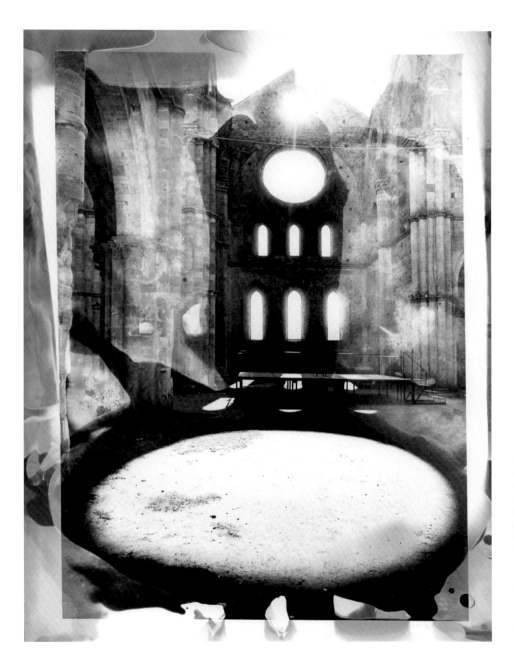

Creativity can also mean doing something new that you have never done before. The analog image on this page was developed in a darkroom. The film-development chemicals were painted on the image with a brush to allow sections of the image to develop at different times. The subject of the image is a large ruin in Tuscany.

This photograph was also taken and developed in a similar manner as the previous one. The Lotus Temple in Delhi, India, is the subject: a place of meditation and prayer for people from every race and religious persuasion. Creativity should free itself from all dogmas and thoughts of how an image should appear, and give free space to all possible ideas.

This photograph depicts people dancing at a club. Multiple movements are captured in the image because a strobe light was running. The creative act is like a dance that gains momentum with ease and joy.

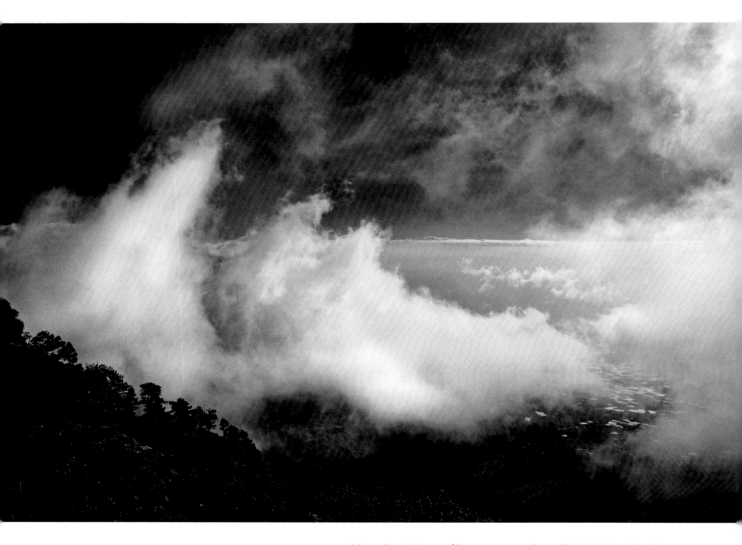

Many descriptions of how to approach meditation insist that the thoughts and ideas that surface in the mind during the practice should be left to pass, like meandering clouds overhead, without being actively acknowledged. Creativity is something different. When creativity strikes, you must allow yourself to be fully taken by it. Don't keep a safe distance like you would with meditation.

Both this image and the one on the opposite page were taken on La Palma in the Canary Islands. It was mesmerizing to watch the morphing cloud formations from the mountain summit and capture them in images while immersed in a meditative practice.

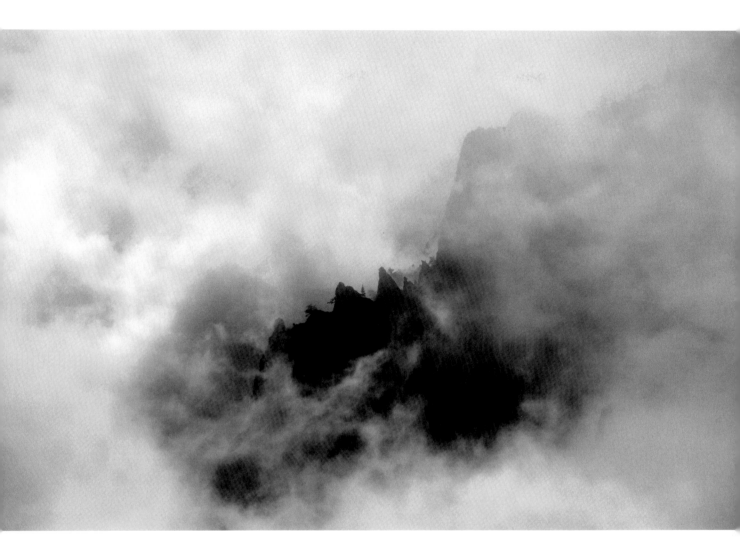

# 26

# Image Design Perceived During Meditation

If you wish to establish a relationship between photography and meditation, there are many options for you to consider. The first possibility is to find a meditative state during the act of photographing images, a subject that I detailed extensively in the chapter "Street Photography." You can also create images that have a meditative quality. Even when in the state of Samadhi, i.e., a state of high alertness, the results may not always be what you initially regard as a meditative image. Conversely, an image that exhibits a meditative character does not necessarily have to have been photographed from a deep meditative state of mind. Considering this point, I would like to share my personal experience:

Although Zen meditation has accompanied me through much of my adult life, in 2005, I started once again practicing 20 minutes a day. I experience the state of meditative calm most often during walks in the mountains, almost always without a camera in hand. There is a place I go with an expansive view where I'm generally undisturbed. I meditate with my eyes open and allow my gaze to wander in the distance, remaining unfixed. Mostly the landscape before me begins to blur after a few minutes. The emptier my mind is, the more likely it is that I have the impression of a rhythmic pattern of light waves passing in front of my eyes. Depending on the light of the

sky, the light waves may seem to pass by in front of a colored area. Because I often meditate at twilight, these colors could be mainly blue-violet, or hues of orange. After two years of a regular meditation practice at this place, I wondered if I could reproduce these visual impressions of unfocused patches of color with the medium of photography.

I picked up a camera, mounted a gray filter on the lens to allow for slower shutter speeds, and experimented with movement and panning of the camera. I gained a lot of experience and discarded a lot of material before I had satisfactory results. After I learned how to move the camera in certain lighting situations, results gradually emerged that reflected the moods I had experienced during meditation. I observed that the images carried color qualities that reminded me of Mark Rothko, one of my favorite painters.

I have reproduced these images in a transparent form cast in glass, which enables light to shine through them from behind. Several people have said that these images have created a meditative mood within their mind.

Whether or not colored images would fit the spirit of Zen is debatable. The classic ink painting shapes that are associated with Zen are almost always created in austere black and white, generally with more areas of white than black. I am of the opinion that even areas of color can inspire Zen meditation.

The following pages contain results of some of these photographs. They are distinguished in two categories and presented without commentary. The first eight images symbolize a state of mind that is pleasantly relaxed, but has not found complete stillness. It is flooded with images and thoughts that are harmoniously interwoven. The images that follow those represent a meditative state of mind that has achieved calm. These images may serve as a stimulus for meditative contemplation. They should not be comprehended by a rational mind, but with a mind that is as still and void of thought as possible. When viewed contemplatively, there should be no expectation that they will trigger something extraordinary.

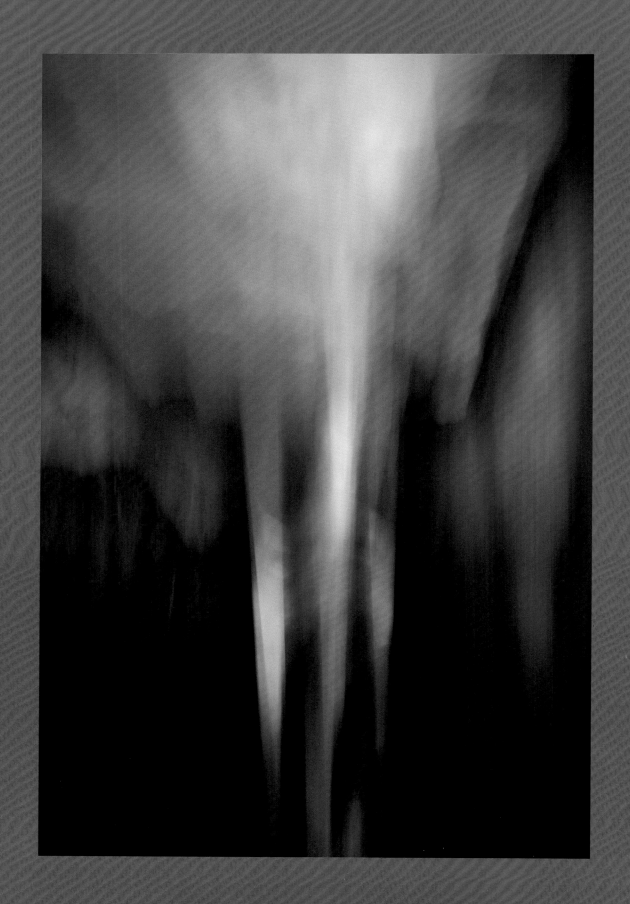

# 27

# Subsequent Critical Analysis and Interpretation

The central objective of this book is to view the intuitive and meditative aspects of photography with the influence and teachings of Zen philosophy. Once this is accomplished, embrace this approach to help develop your own personal creativity and become aware of what you really want to express. In this book I have dealt minimally with the technical elements of photography and focused on the creative aspects of the art of photography. Just as we need the rational side of our brain when photographing images, we also need to tap into our emotional mind—just at different times. The technical aspects of photography should be second nature to you before you attempt this type of photography. If this is not the case, you may also like to work with the automatic functions of the camera to make it easier to enter a meditative state of mind. Furthermore, there are countless good books about the technical aspects of photography to support your process.

The tangible rules of the art of photography are described in my book, *The Art of Black and White Photography*, which is also available from this publisher. The classical laws of image composition, such as the golden section or triangular composition, are discussed in detail in this book. It is an important requisite to master the technical aspects of photography and know the classic rules of image composition. This knowledge is very useful in viewing and critiquing your images, which you should do after you take photographs.

The evaluation of images is performed with the rational side of the brain and does not have much to do with meditation, but is also very important. After capturing images, it is important to critique them and separate the wheat from the chaff. Once you have selected the successful images, enhance them with an image-editing software program such as Photoshop or Lightroom. I will not discuss methodology of image processing in this book, but this publisher has many excellent textbooks available.

In analog photography, especially black-and-white photography, the mood of an image relates back to your work in the darkroom. The same holds true for digital photography. It is important to master the technique of partial progress, which means to work on specific sections of an image: brightening or darkening them, for example, or reducing or enhancing color saturation. Accomplishing this is relatively easy using image-editing software and is further explained in my book, *The Art of Black and White Photography*.

How one perceives the mood of an image is a matter of emotion and intuition. For example, the contrast in images that appear in magazines is often increased too much, resulting in unnatural color saturation. If you increase the contrast in color images, you generally have to slightly reduce the color saturation so that the images remain natural. You'll need a good monitor with calibrated color for image processing, as well as a good printer or darkroom. In any case, I recommend that you not only view the images on the monitor, but also edit them thoroughly and print them or have them printed. A printed image has a tactile attraction; you can touch it and feel it. An image displayed on the monitor is not comparable to the sight and experience of a print. After reading and considering the information in this book about deepening your creative approach to photography, I would like to offer something tangible for those who might want it. In the last chapter, "The Path to Your Own Style," I will provide instruction on how to develop your own personal photographic style.

# 28

# The Path to Your Own Style

Accomplishing expressive photography and developing your own photographic style cannot be learned by following a recipe, just as there is no recipe for meditation. Nevertheless, I would like to offer an instructional guide that provides tangible tips for interested readers. Of course, if this does not interest you, you can simply skip this chapter.

### Step 1: 20-Minute Meditation
Meditate as outlined in Chapter 4, "The Practice of Zazen." For at least 20 minutes, allow your mind to become as empty of thoughts as possible.

### Step 2: Where is Your Place?
Refer to Chapter 15, "Inner and Outer Landscapes." Allow yourself at least half an hour, lie down on a blanket, and relax in silence or with meditative music. Once you are very relaxed, try to imagine places you are drawn to. What kind of place casts a special spell over you? What kind of place has a powerful pull over you? Decide whether large, general places like Paris, Patagonia, or Lanzarote, or smaller, very specific places such as the Jewish cemetery around the corner, a certain old mine in a former industrial area, or Potsdam Square in Berlin attract you. This may inspire you to visit potential destinations or discover locations closer to home. When different places appear in your mind's eye, please observe if you also feel a resonance in your abdomen. The area in the abdomen, slightly below the

navel, is the "Hara," an anatomical center especially important in Zen. That is the place of your intuition, also referred to in English as the "gut feeling."

If you have summoned places in your mind's eye that produce a positive response in you, repeat the exercise and allow yourself to imagine places that might be unpleasant or that have a negative effect. Thoroughly examine and try to remember all of these places. Relax for five more minutes and end the meditation lying down. Then, record your experiences. This will prepare you for an intensive photo session. Select one of the destinations that appeared exciting (and that is accessible) to you. Schedule a day where you can go there alone.

## Step 3: Your Photo Day

On the day you plan to travel to your chosen location, begin the morning with a 20-minute meditation, during which you find your way to a joyous mood of intense expectation. As you are underway, embrace the idea that you are entirely free on this day to express yourself with your camera.

When you reach your destination, please do not expect exciting images to be immediately obvious. Resolve yourself to the knowledge that you have a lot of time, and realize how satisfying it will be to capture a very few, special photos. Be completely present in the location. If you have chosen to visit a city, go beyond the homogeneous pedestrian areas and tourist sights. Search for seemingly insignificant alleys and peer into backyards. If you are outside, encounter nature and try to discover perspectives beyond the typical cliché images. Try to free yourself from all the notions of what you would like to photograph and start to embrace your environment completely. It is beneficial if you refrain from thinking actively and just allow yourself to observe and feel.

There will come a moment when you sense the first photographic subject, even if you do not yet feel great enthusiasm. Nevertheless, begin taking photographs. Pay special attention to whether or not you feel an inner resonance when viewing and photographing the scene. If you do, begin to compose your subject by observing your shots repeatedly in the image display screen. Ask yourself if the composition appears harmonious. Are there any superfluous elements you could exclude

by selecting a different perspective? Continue to take photographs until you are satisfied.

With time, you can gradually find a mood of enthusiasm, and it will be easier to discover more motifs that resonate within. This successful mood is not easily described; again, it relates to that gut feeling. The famous black-and-white photographer, Robert Häusser, summed it up in simple words: he described driving through the countryside until he has the feeling, "here is something," as though an internal divining rod directed his attention. I describe this feeling as having such a strong response to a scene that you suddenly forget everything else, including physical and intellectual sensations and thoughts, and even time and yourself. I explained this concept in Chapter 7, "File Drawers and Immediate Experience," but everyone will perceive this differently.

If such an intense feeling does not develop further, do not be discouraged. I have experienced days where I have not successfully found the right mood and have only produced mediocre photographs. This mood cannot be forced. An opportunity cannot present itself; it can only be a gift. Please do not be disappointed if, on your first day of intensive meditative photography, you are not as successful as you had hoped. It might be that you are in the wrong location, or the deep intent of what you wanted to express was not quite clear. Or, you might be still too connected to your everyday life and not totally free to fully encounter a scene. If this seems to be your issue, sometimes vacations can lend themselves to producing more successful results. If you are planning an intense day of photography during a vacation, please approach the day as I have described. And please, experience this day alone. You should not be encumbered by the feeling that someone is waiting on you.

If on your first day of conscious meditative photography you have succeeded in capturing this mood of inspiration and enthusiasm that I have described, you will notice your photo session develop like waves. At times you are intensely present, then the wave of presence ebbs, only to swell again. When you sense the mood weakening, you can consider taking a break. Afterwards, you should evaluate if that "excitement" can be rekindled. If you feel the momentum, enjoy the second part of

your photo session. Take photographs until you no longer feel drawn to your subject, then wrap up your meditative photo session and allow the day to end in a pleasant way.

## Step 4: Review and Evaluation of Your Results

This step is challenging, because it is easy to wear "blinders" when reviewing your own work, thus failing to see deficiencies in the results. You should still give it a try. Select at least 20, or better yet, 30 photographs that you find halfway interesting. Edit these photographs as well as you can with image-editing software like Photoshop or Lightroom. Print the edited images in a size of at least 8"×10". Place all of these prints on a large table or on the floor so you can view them. You can also enlist the help of friends, partners, or acquaintances. Otherwise, you can view your images alone.

Consider the first question: Which images have the strongest power of expression? Do not overthink this. Select the images intuitively and arrange them so that they are next to each other.

Consider the second question: Which images have the least expressive power or are the weakest? Select these prints and group them together as well.

The images you have labeled as "strong" have shown you the way! Ask yourself what content or form these images have in common. What is the common denominator or what themes can you detect in these images? What kinds of feelings or moods do these images create? Discuss these questions openly and honestly. You have now come closer to what you really would like to express, thus developing your own creativity and your own style!

Turn to the group of images that you felt were weak photographs. Repeat the analysis and discuss why you feel these were less successful. Mostly, you will find that the composition is not concentrated enough. Using white sheets of paper, try to frame sections within the images that you feel are powerful. You may find that smaller sections produce far better photographs. Draw a conclusion from this analytical review and accept this as the basis for your next meditative photographic day.

## Step 5: Making Further Strides

Lay back and try to relax. Reflect once again on the results of your image analysis. Again ask yourself what it was about those photographs that interested you the most, and what themes you can find in the strongest images. What are the basic emotions that you want to express the most? Even if these emotions are negative feelings such as sadness, fear, or loneliness, you should be honest with yourself and stand by these sensations. Once you have answered these questions, you should think about which location would best help you explore these themes and emotions. If you have trouble arriving at a clear answer, return to the process another day and work towards clarity. After your first conscious photo session, you will more easily be able to select a location for your second day. It could be the same place.

In this manner you can continue to make progress. You might undertake a little photo trip to a destination farther away that holds a specific attraction. Remember that such a trip should be taken alone, or with someone who will allow you the freedom to embark on your personal photographic journey.

The next step would be to repeat the analysis process using your new images in the hope that over time your photographic path becomes continually clearer.

I wish you much joy and success.

Torsten Andreas Hoffmann
www.t-a-hoffmann.de

### Also by Torsten Hoffmann

Torsten Andreas Hoffmann
*The Art of Black and White Photography,
2nd Edition*
*Techniques for Creating Superb Images
in a Digital Workflow*

Rocky Nook, Inc.
ISBN 978-1-933952-96-3
$44.95 (US)  $46.95 (CAN)